# Naïve Art

NATALIA BRODSKAIA

PARKSTONE PRESS

© 2000 Artists Rights Society ARS, New York / ADAGP, Paris
All rights reserved

Published in 2000 by Parkstone Press USA
180, Varick Street, 9th floor
New York, NY 10014

ISBN 1 85995 335 2
© Parkstone Press, USA 2000

Publishing Director : Jean-Paul MANZO
Text : Natalia BRODSKAIA
Translation and adaption : Mike DARTON
Publishing Assistants : Paula VON CHMARA Aurélia HARDY
Design and layout : Newton Harris - Design Partnership
Cover and jacket : Cédric PONTES
Chapter 7 : Viorel RAU

We are very grateful to :
Mr. Mike Darton
Art Expo Foundation, Bucarest
Mr. Radu Lungu

# Naïve Art

*"Who are we? What are we? Where are we going?"*
**Paul Gauguin**

We are very grateful to Mr Mike Darton

**A** Romanian painting

# Contents

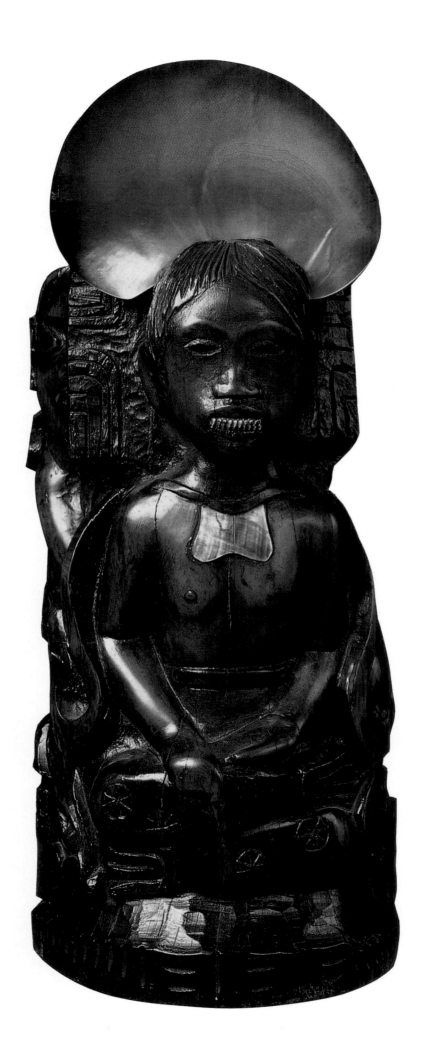

**B Paul Gauguin**

*Idol with Shell* (sideview),
1892

Wooden statuette, mother-of-pearl
teeth in bone, 27 x 14 cm

Musée d'Orsay (Plate from R.M.N.)

# Foreword

## How old is *Naïve* Art?

There are two possible ways of defining when *naïve* art originated. One is to reckon that it happened when *naïve* art was first accepted as an artistic mode of status equal with every other artistic mode. That would date its birth to the first years of the twentieth century. The other is to apprehend *naïve* art as no more or less than that, and to look back into human prehistory and to a time when all art was of a type that might now be considered naïve – tens of thousands of years ago, when the first rock drawings were etched and when the first cave-pictures of bears and other animals were scratched out. If we accept this second definition, we are inevitably confronted with the very intriguing question, 'So who *was* that first *naïve* artist?'

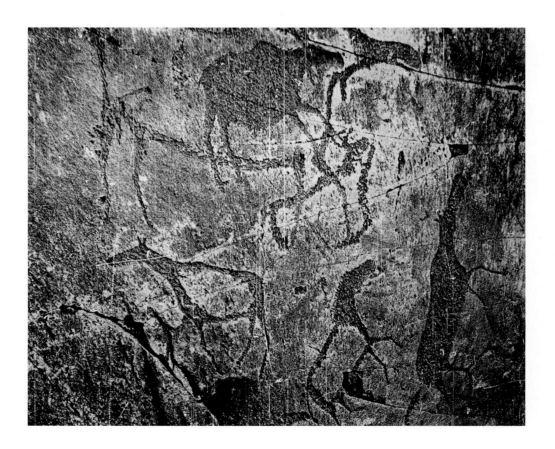

1 Valley of the Ienissei, Siberia, Oglachti, 10000-6000 BC

Many thousands of years ago, then, in the dawn of human awareness, there lived a hunter. One day it came to him to scratch on a flattish rock surface the contours of a deer or a goat in the act of running away. A single, economical line was enough to render the exquisite form of the graceful creature and the agile swiftness of its flight. The hunter's experience was not that of an artist, simply that of a hunter who had observed his 'model' all his life. It is impossible at this distance in time to know why he made his drawing. Perhaps it was an attempt to say something important to his family group; perhaps it was meant as a divine symbol, a charm intended to bring success in the hunt. Whatever – but from the point of view of an art historian, such an artistic form of expression testifies at the very least to the awakening of individual creative energy and the need, after its accumulation through the process of encounters with the lore of nature, to find an outlet for it.

This first-ever artist really did exist. He must have existed. And he must therefore have been truly 'naïve' in what he depicted because he was living at a time when no system of pictorial representation had been invented. Only thereafter did such a system gradually begin to take shape

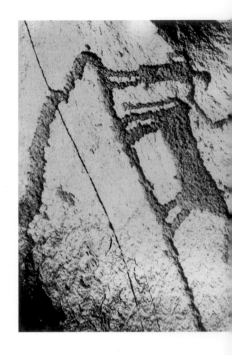

2 Thian Chan, Saimali-tach, 4000-2000 BC

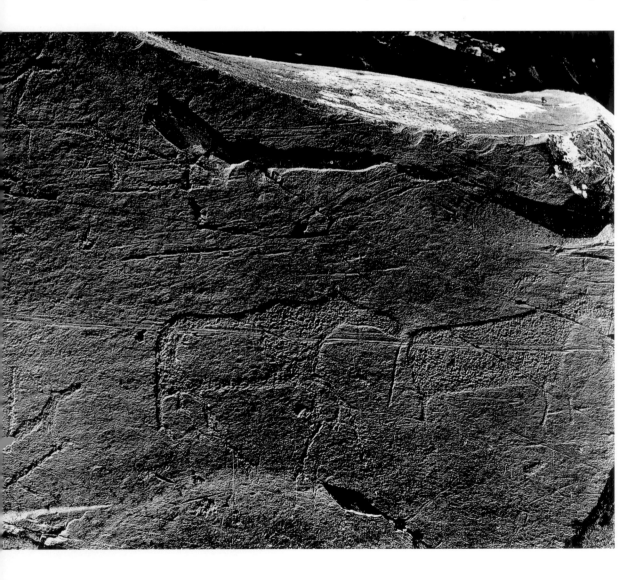

3 Siberia, 6000-4000 BC

and develop. And only when such a system is in place can there be anything like a 'professional' artist. It is very unlikely, for example, that the paintings on the walls of the Altamira or Lascaux caves were creations of unskilled artists. The precision in depiction of the characteristic features of bison, especially their massive agility, the use of chiaroscuro, the overall beauty of the paintings with their subtleties of coloration – all these surely reveal the brilliant craftsmanship of the professional artist. So what about the 'naïve' artist, that hunter who did not become professional? He probably carried on with his pictorial experimentation, using whatever materials came to hand; the people around him did not perceive him as an artist, and his efforts were pretty well ignored.

Any set system of pictorial representation – indeed, any systematic art mode – automatically becomes a standard against which to judge those who through inability or recalcitrance do not adhere to it. The nations of Europe have carefully preserved as many masterpieces of classical antiquity as they have been able to, and have scrupulously also consigned to history the names of the classical artists, architects, sculptors and designers. What chance was there, then, for some lesser

**4** Valley of the Ienissei, Siberia, Oglachti, 10000–6000 BC Detail

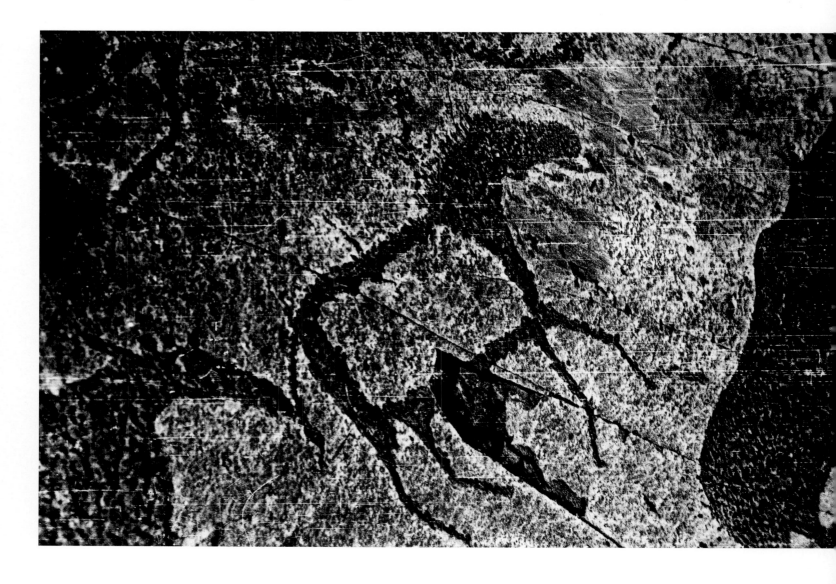

mortal of the Athens of the fifth century BC who tried to paint a picture, that he might still be remembered today when most of the ancient frescoes have not survived and time has not preserved for us the easel-paintings of those legendary masters whose names have been immortalized through the written word? The name of the Henri Rousseau of classical Athens has been lost forever – but he undoubtedly existed.

5 Valley of the Ienissei, Siberia, Oglachti, 10000-6000 BC Detail

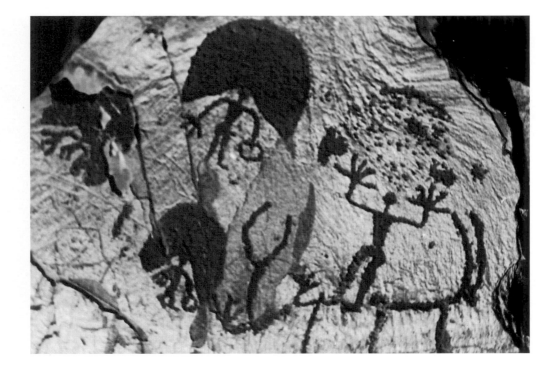

6 Thian Chan, 4000-2000 BC

The Golden Section, the 'canon' of the (ideal proportions of the) human form as used by Polyclitus, the notion of 'harmony' based on mathematics to lend perfection to art – all of these derived from one island of ancient civilization adrift in a veritable sea of 'savage' peoples: that of the Greeks. The Greeks encountered this tide of savagery everywhere they went. The stone statues of women executed by the Scythians in the area north of the Black Sea, for example, they regarded as barbarian 'primitive' art and its sculptors as 'naïve' artists oblivious to the laws of harmony.

As early as during the third century BC the influence of the 'barbarians' began to penetrate into Roman art, which at that time was largely derivative of Greek models. The Romans believed not only that they were the only truly civilized nation in the world but that it was their mission to civilize others out of their uncultured ways, to bring their primitive art forms closer to the rigorous standards of the classical art of the Empire. All the same, Roman sculptors felt free to interpret form in a 'barbaric' way, for instance by creating a sculpture so simple that it

7  Siberia, 6000-4000 BC

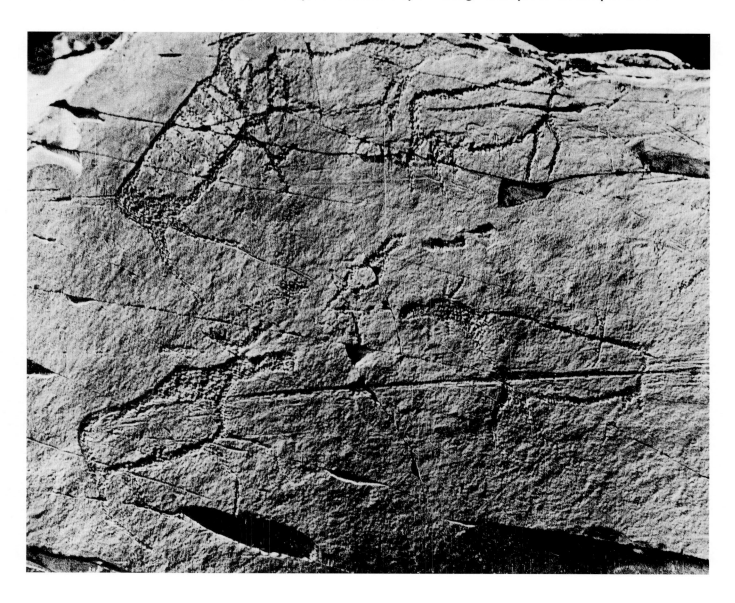

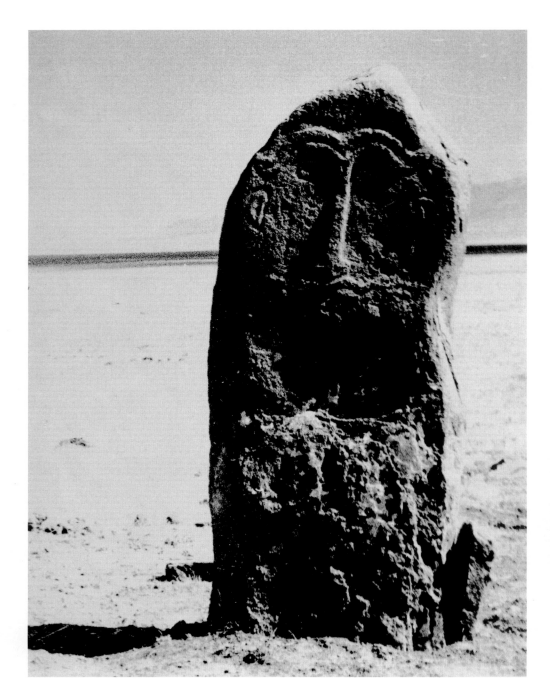

10 Baba-Scythe statue

11 Baba-Scythe statue

looked primitive and leaving the surface uneven and only lightly polished. The result was ironically that the 'correct' classical art lacked that very impressiveness that was characteristic of the 'wrong' barbaric art. In the light of this it is not unreasonable to suggest that Picasso, Mirrface uneven and only lightly polished. The result was ironically that the 'correct' classical art lacked that very impressiveness that was characteristic of te years before in the third century BC.

Having overthrown Rome's domination of most of Europe, the 'barbarians' dispensed with the classical system of art. It was as if the 'canon' so notably realized by Polyclitus had never existed. Now art learned to frighten people, to induce a state of awe and trepidation by its expressiveness. Capitals in the medieval Romanesque cathedrals swarmed with strange creatures with short legs, tiny bodies and huge heads. Who

12 Baba-Scythe statue

13 Baba-Scythe statue

carved them? Very few of the creators' names are known. Undoubtedly,
however, they were excellent artisans, virtuosi in working with stone. They
were also true artists, or their work would not emanate such tremendous
power. These artists came from that parallel world that had always
existed, the world of what Europeans called 'primitive' art.

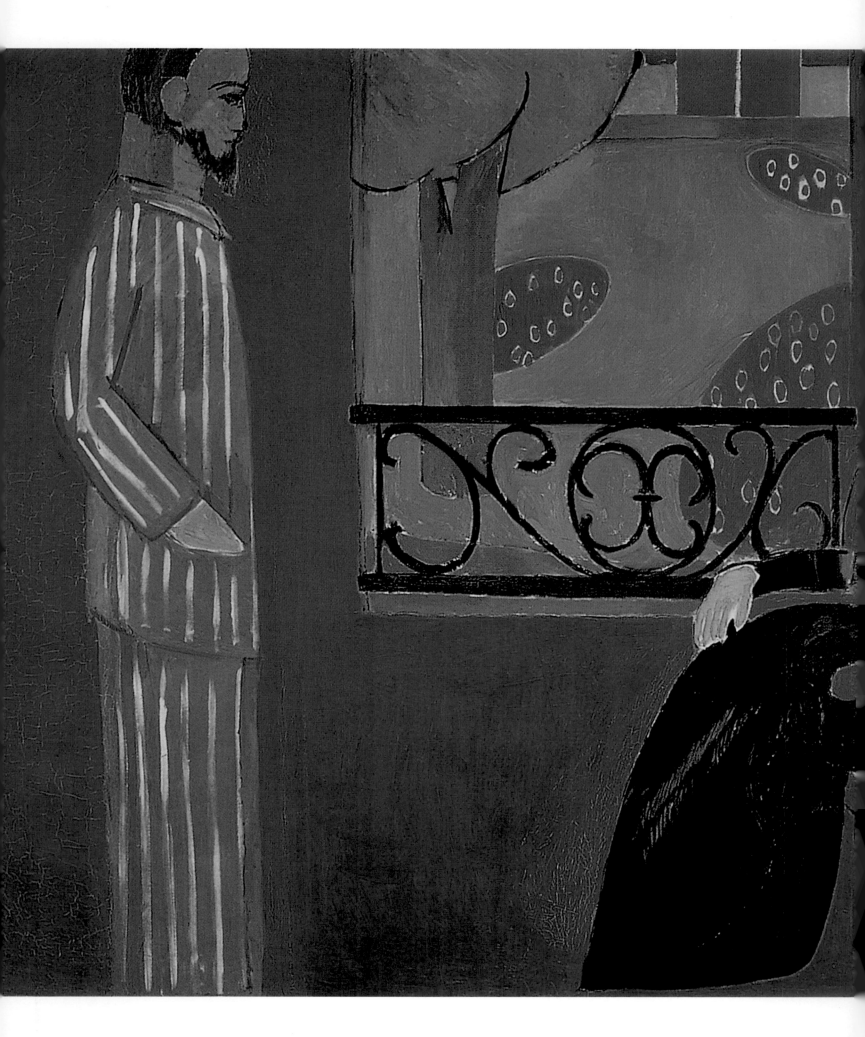

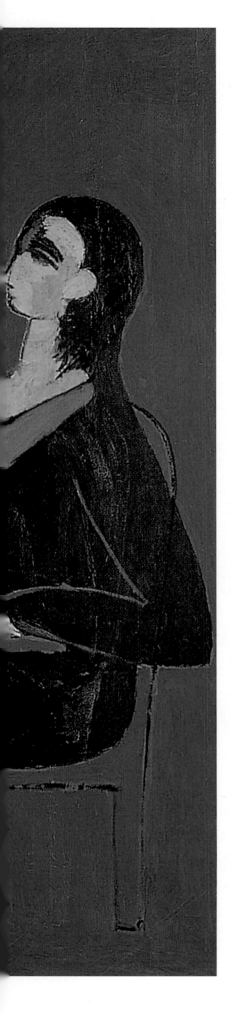

# Reflections on Naïve Art

'Naïve' art, and the artists who created it, became well known in Europe at the beginning of the twentieth century. Who were these artists, and what was their background? To find out, we have to turn back the clock and look at the history of art at that time.

It is interesting that for much of the intervening century, the *naïve* artists themselves seem to have attracted rather less attention than those people responsible for 'discovering' them or publicizing them. Yet that is not unusual. After all, the *naïve* artists might never have come into the light of public scrutiny at all if it had not been for the fascination that other young European artists of the avant-garde movement had for their work - avant-garde artists whose own work has now, at the turn of the millennium, also passed into art history. In this way we should not consider viewing works by, say, Henri Rousseau, Niko Pirosmani, Ivan Generalic, André Bauchant or Louis Vivin without reference at the same time to the ideas and styles of such recognized masters as Pablo Picasso, Henri Matisse, Joan Miró, Max Ernst and Mikhail Larionov.

But of course, to make that reference itself presents problems. Who was influenced by whom, in what way, and what was the result? The work of the *naïve* artists poses so many questions of this kind that experts will undoubtedly still be trying to unravel the answers for a good time yet. The main necessity is to establish for each of the *naïve* artists precisely who or what the main source of their inspiration was. This has then to be located within a framework expressing the artist's relationship to the 'classic' academic ('official') art of the period. Difficult as it is to make headway in such research, matters are further complicated by the fact that such questions may themselves have more than one answer – and that each answer may be subject to different interpretation by different experts anyway.

It gets worse. All the time the works of previously unknown *naïve* artists are coming to light, some of them from the early days of *naïve* art, some of them relatively contemporary. Their art may add to our

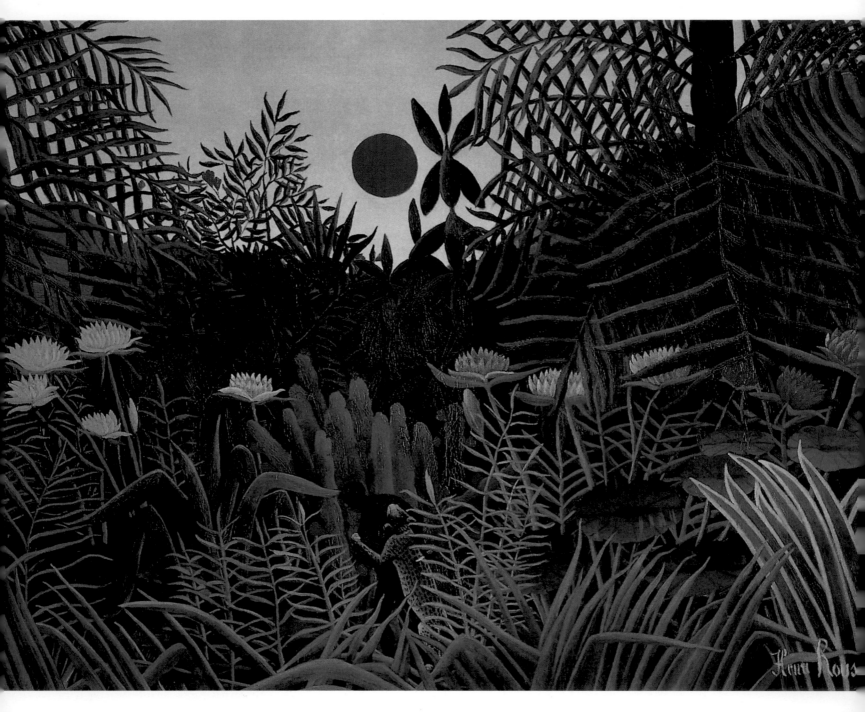

understanding of the phenomenon of *naïve* art or may change it altogether.
For this reason alone it would simply not be feasible to come to an
appreciation of *naïve* art that was tightly-defined, complete and static.

In this study, therefore, we will contemplate only those
outstanding – yet outstandingly diverse – examples of *naïve* art that really
do constitute pointers towards a genuine style, a genuine direction in
pictorial representation, albeit one that is currently little known. Think of
this book, if you like, as a preliminary sketch for a picture that will be
completed by future generations.

It is difficult – perhaps even impossible – to quantify the
influence of Henri Rousseau, Niko Pirosmani and Ivan Generalic on
professional 'modern' artists and the artworks they produce. The reason is

14 **Henri Rousseau**
*A Negro Attacked by a
Panther*, ca. 1910
Oil on canvas, 114 x 162 cm
Museum of Arts, Basel

obvious: the three of them belonged to no one specific school and, indeed, worked to no specific system of art. It is for this reason that genuine scholars of *naïve* art are somewhat thin on the ground. After all, it is hard to find any basic element, any consistent factor, that unites their art and enables it to be studied as a discrete phenomenon.

The problems begin even in finding a proper name for this kind of art. No single term is descriptive enough. It is all very well consulting dictionaries – they are not much use in this situation. A dictionary definition of a 'primitive' in relation to art, for example, might be 'An artist or sculptor of the period before the Renaissance'. This definition is actually not unusual in dictionaries today – but it was first written in the nineteenth century and is now badly out of date because the concept of 'primitive' art has expanded to include the art of non-European cultures in addition to the art of *naïve* artists worldwide. In incorporating such a massive diversity of elements, the term has thus taken on a broadness

**15  Niko Pirosmani**
*A Woman Milking a Cow,*
1916
Oil on cardboard, 31 x 100 cm
Georgian Museum of Fine Arts,
Tbilisi

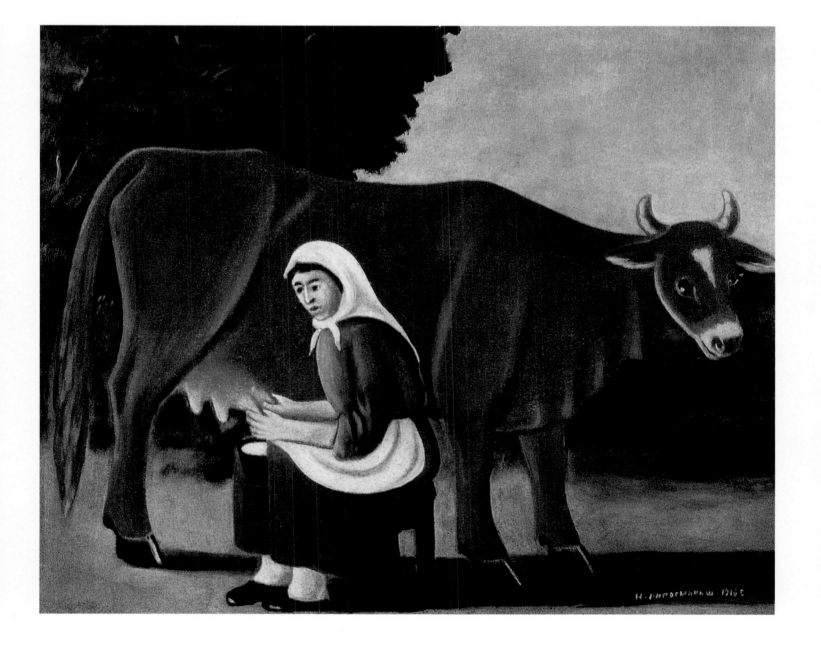

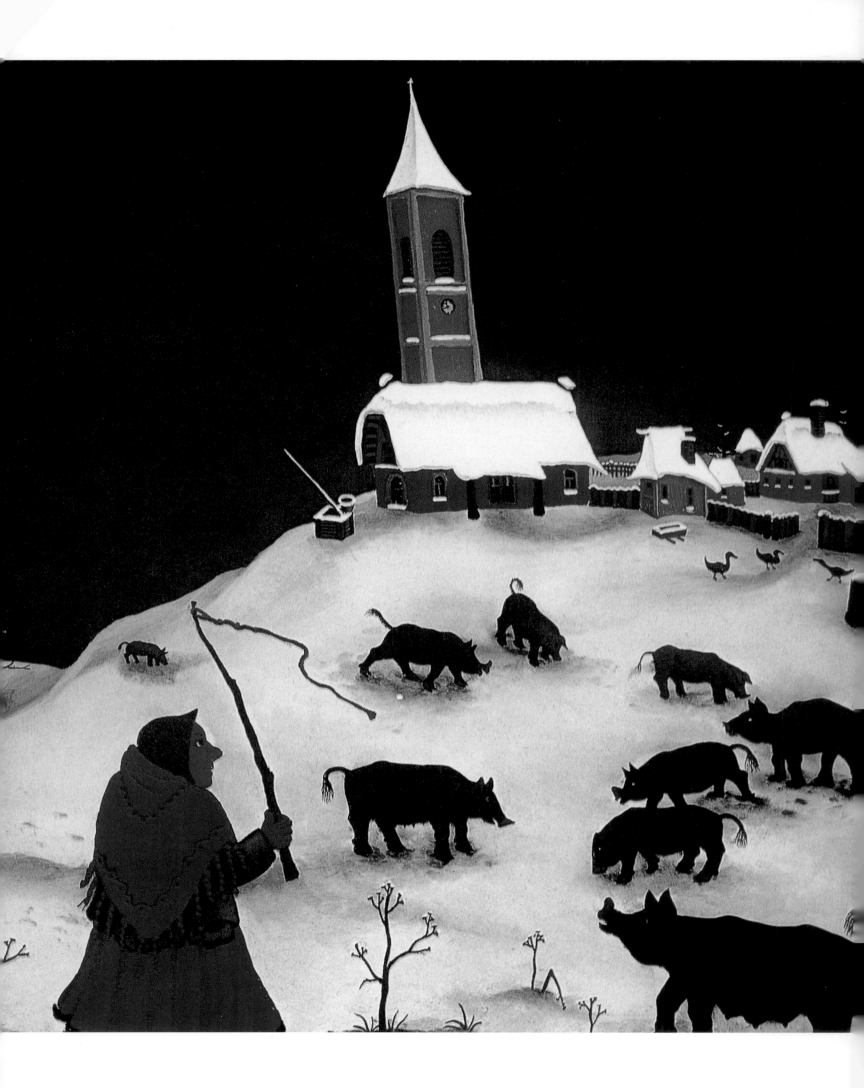

that renders it, as a definition, all too indefinite. The description 'primitive' is simply no longer precise enough to apply to the works of untaught artists.

The word 'naïve', which implies naturalness, innocence, unaffectedness, inexperience, trustfulness, artlessness and ingenuousness, has the kind of descriptively emotive ring to it that clearly reflects the spirit of such artists. But as a technical term it is open to confusion. Like Louis Aragon, we could say that 'It is naïve to consider this painting naïve.'[1]

17 **André Bauchant**
*Rocky Landscape*

Many other descriptive expressions have been suggested to fill the gap. Wilhelm Uhde called the 1928 exhibition in Paris *Les Artists du Sacré-Coeur*, apparently intending to emphasize not so much a location as the unspoiled, pure nature of the artists' dispositions. Another proposal was to call them 'instinctive artists' in reference to the intuitive aspects of their method. Yet another was 'neo-primitives' as a sort of reference to the idea of nineteenth-century-style 'primitive' art while yet distinguishing them from it. A different faction picked up on Gustave Coquiot's observation in praise of Henri Rousseau's work and decided they should be known as 'Sunday artists'.

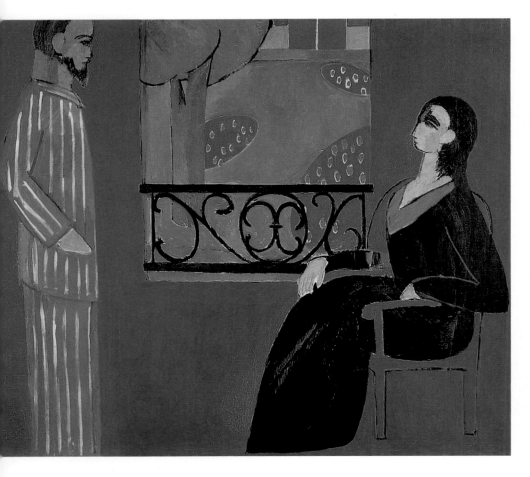

**18 Henri Matisse**
*Conversation*, 1909
Oil on canvas, 117 x 217 cm
Hermitage, St Petersburg

**19 Mikhail Larionov**
*A Fruitshop*, 1904
Oil on canvas, 66 x 69 cm
Russian Museum, St Petersburg

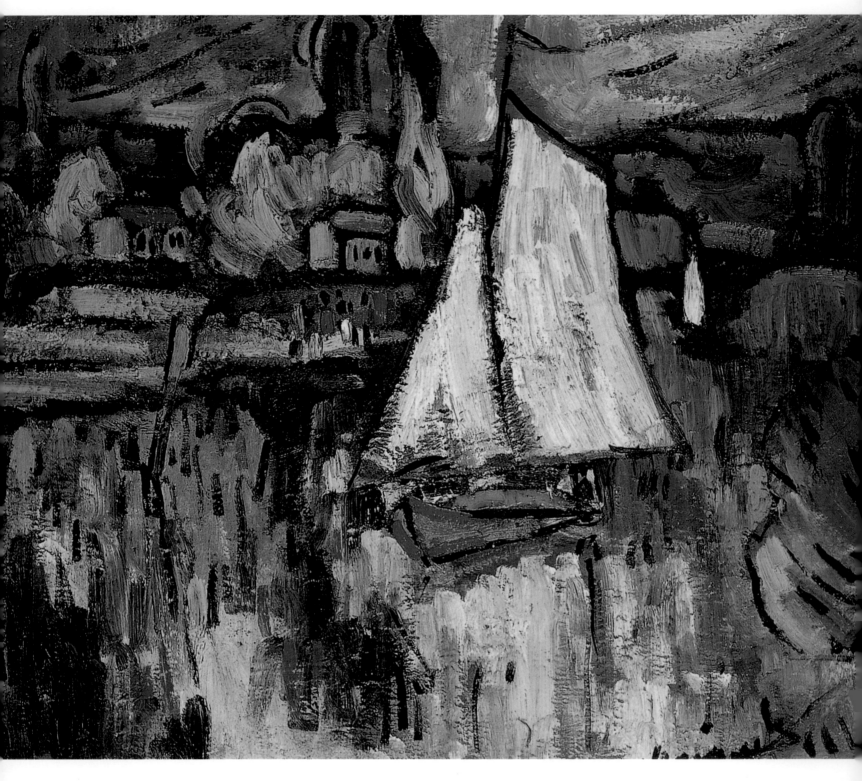

Of all the various terms on offer, it was *naïve* that won out. This
is the word that is used in the titles of books and in the names of a
growing number of museums. Presumably, it is the combination of moral
and aesthetic factors in the work of *naïve* artists that seems appropriate in
the description. Gerd Claussnitzer alternatively believes that the term is
meant pejoratively, as a nineteenth-century comment by the realist school
on a visibly clumsy and unskilled style of painting.[2] For all that, to an
unsophisticated reader or viewer the term '*naïve* artist' does bring to mind
an image of the artist as a very human sort of person.

20 **Maurice de Vlaminck**
*View on the Seine*, 1905-1906
Oil on canvas, 54.5 x 65.5 cm
Hermitage, St Petersburg

Every student of art feels a natural compulsion to try to classify the *naïve* artists, to categorize them on the basis of some feature or features they have in common. The trouble with this is that the *naïve* artists – as noted above – belong to no specific school of art and work to no specific system of expression. Which is precisely why professional artists are so attracted to their work. Summing up his long life, Maurice de Vlaminck wrote: 'I seem initially to have followed Fauvism, and then to have followed in Cézanne's footsteps. Whatever – I do not mind . . . as long as first of all I remained Vlaminck.'[3]

*Naïve* artists have been independent of other forms of art from the very beginning. It is their essential quality. Paradoxically, it is their independence that determines their similarity. They tend to use the same sort of themes and subjects; they tend to have much the same sort of outlook on life in general, which translates into much the same sort of painting style. And this similarity primarily stems from the instinctual nature of their creative process. But this apart, almost all *naïve* artists are or have been to some extent associated with one or other non-professional field of art. The most popular field of art for *naïve* artists to date has been folk art.

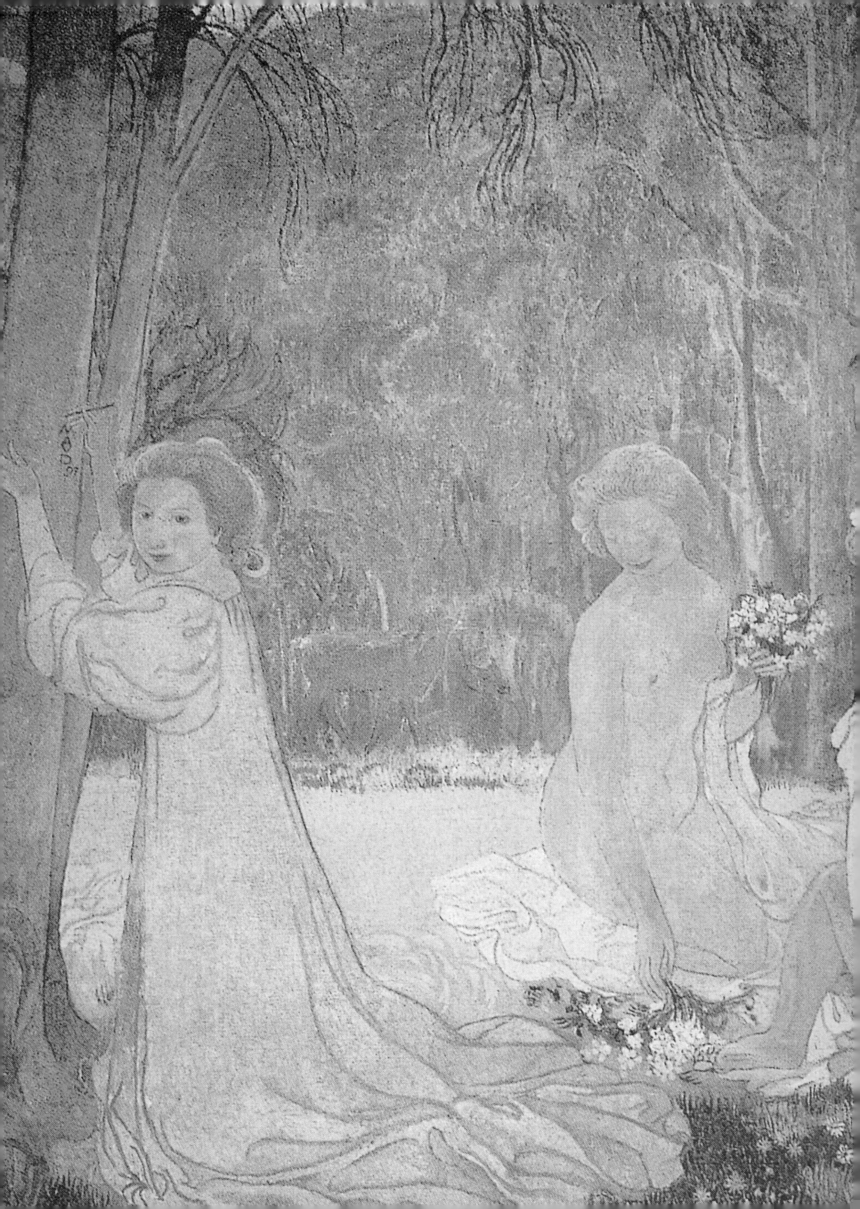

# Modern Art in Quest of New Material

7

## The New Century – 'Primitives' and 'the Decline of the West'

The rebellion of Romanticism against classicism, and the resultant general enthusiasm for artworks that broke the classical mould, set the scene for the events that took place on the threshold between the nineteenth and twentieth centuries. Classical painting styles became obsolete: even its die-hard champions realized that classicism was in crisis. Historical and *genre* painting as featured in the Paris *salons* had taken to treating Leonardo's dictum that 'art should be a mirror-image of reality' as an excuse for mere vulgarity in a way that the great Italian master had certainly never envisaged. Admiration for the ancient world had turned

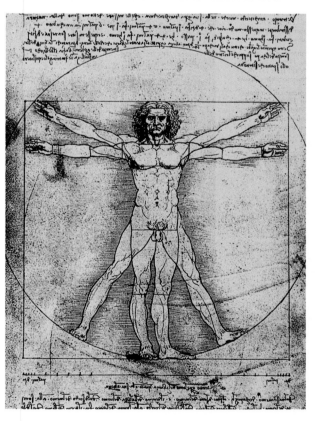

21 **Léonardo da Vinci**
*Scale of Human Proportions According to Vitruvius*
Pen and ink drawing, 34.4 x 24.5 cm
Accademia, Venice

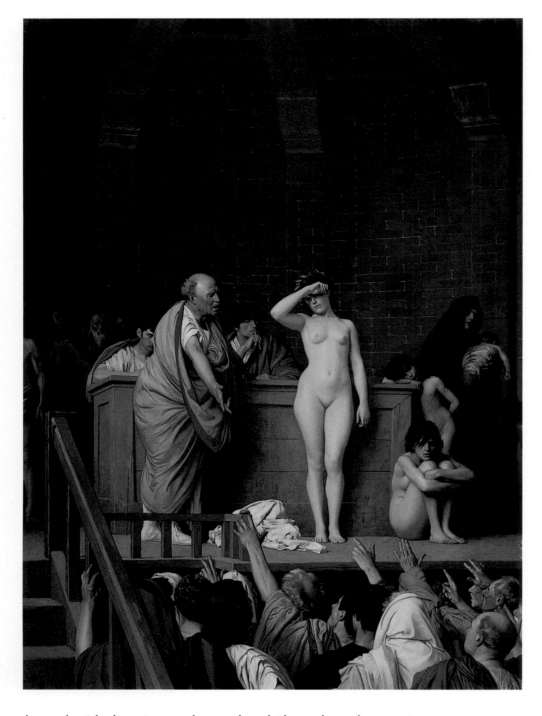

22 **Jean-Léon Gérôme**
*The Selling of a Female Slave*
Oil on canvas, 92 x 74 cm
Hermitage, St Petersburg

from slavish devotion to the works of Plutarch to the prurient sentimentality embodied in such works as Jean-Léon Gérôme's *The Auction of a Female Slave*. Similarly, the burgeoning interest in the attractions of the mysterious East had resulted in no more than a host of portrayals of nude beauties in tile-lined pools.

At the same time, the quest for natural depiction, for reality of presentation, had stimulated the development of photography – which at one stage was a bitter rival of painting. After all, André Malraux quite rightly said that the one and only preoccupation of photography should be to imitate art. In an endeavour somehow to outdo photography on its own terms, painters resorted to copying three-dimensional nature in minutely refined detail, using myriad brushstrokes. This was in itself nothing less

than an acknowledgement of painting's incapacity and defeat. And such was the end of the Academy's domination, which had lasted since the seventeenth century. The most liberated of the artists of the Romantic era no longer bothered much with reality of presentation: photography, by reproducing reality as an instant of three-dimensional history caught forever, caused the final departure from it.

23 **Hugues Taraval**
*The Bathing of Venus*
Oil on canvas, 100 x 82 cm
Pushkin Museum of Fine Arts,
Moscow

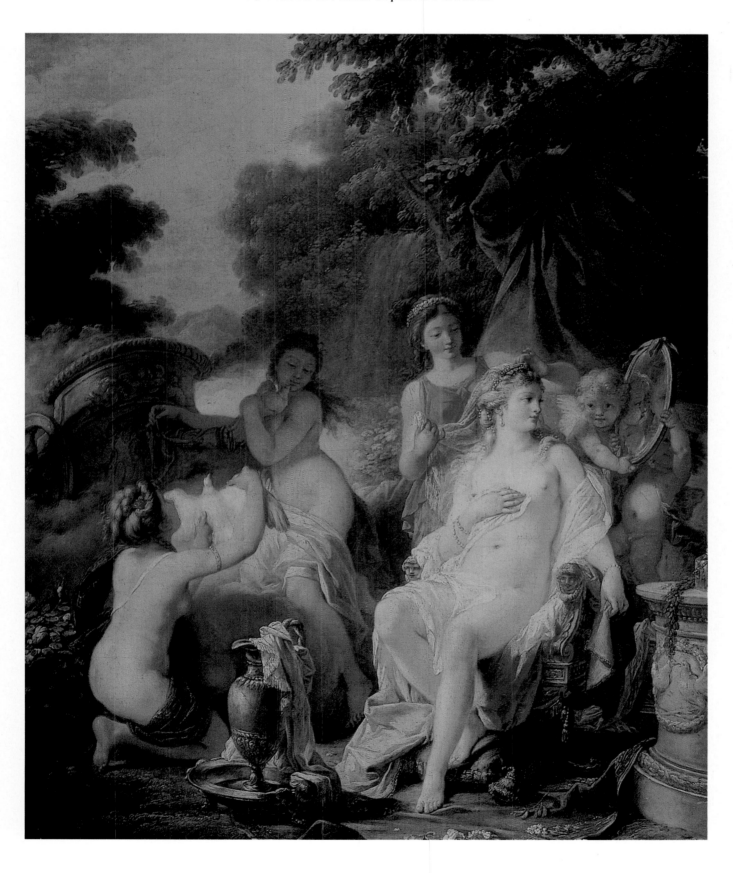

The famous words of Maurice Denis, written when he was only twenty years old in 1890, take on a special significance in this respect. 'Remember that a picture – before becoming a war-horse or a nude woman or a scene from a story – is essentially a flat surface covered with colours assembled in a particular order.'[4] It was the masters of the very early Renaissance years, already known customarily as 'primitives' in nineteenth-century Europe, whose work could be used to provide guidance in understanding the role of the flat surface as the basis for colour. And this heritage had the potential to lead to that new Renaissance which the future Impressionists dreamt of in their youth.

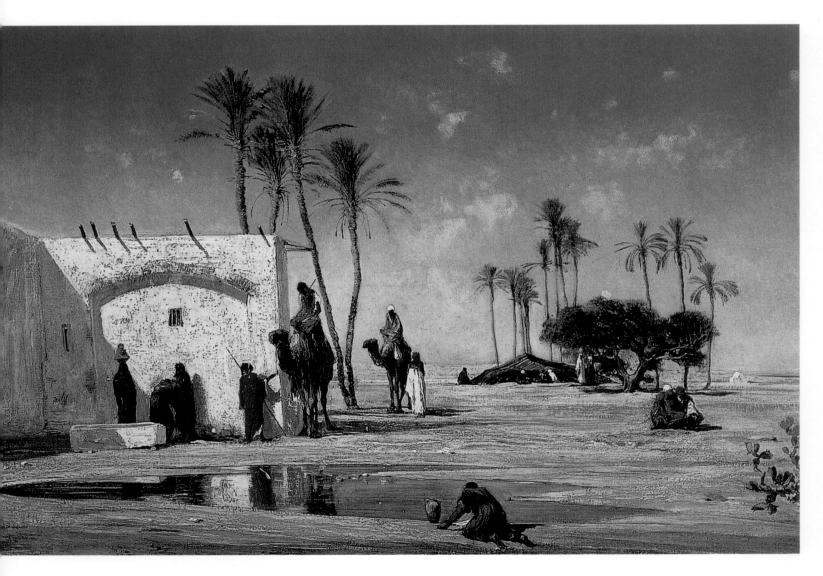

24 **Victor-Pierre Huguet**
*Oriental Landscape*
Oil on canvas, 41 x 61 cm
Museum for Eastern and Western Art, Odessa

What the noted German philosopher Oswald Spengler called *Der Untergang des Abendlandes*, 'the decline of the West' (which was the title of his book), was also a powerful factor that increased the divide between artists who chose to look back to the system of the classical ancients and artists who had no truck with such criteria. Political Eurocentrism collapsed under the pressure of a complex multitude of pressures, and did so at precisely this time – the threshold between the two centuries. Yet by

then European artists had already for some time been on the look-out to learn new things from other parts of the world. So, for instance, in their research into the 'mysterious East', the Romantic youth of the 1890s were also examining Japanese and Chinese art as part of a search for different approaches to the 'flat surface' about which Maurice Denis had written. Closer to home, Islamic art – 'primitive' in the most accomplished sense of the word – rose to considerable popularity during the first decade of the twentieth century, which increased following large exhibitions in Paris and in Germany.

But the biggest boost to the new form of Romantic art came in the form of a massive influx of works from the 'primitive' world – some from Central and South America, but most from Africa – that poured into Europe at the turn of the twentieth century, chiefly through colonial agents. Until this time, the only conceivable description of works of art from these areas was as 'primitive'. The marvellous gold artefacts

25 **Maurice Denis**
*Faces in a Spring Landscape (The Sacred Wood)*
Oil on canvas, 94 x 120 cm
Pushkin Museum of Fine Arts, Moscow

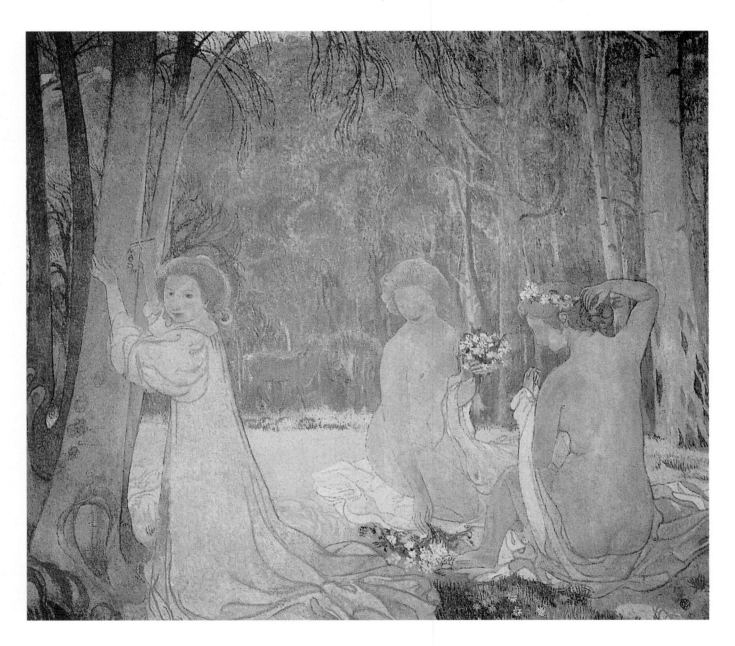

fashioned by native Peruvians and Mexicans, which flooded Europe following the discovery and colonization of their lands, were regarded simply as precious metal to be melted down and reworked. Museums did keep and display items from Africa and the Pacific, but little interest was shown in obtaining them.

However, by the end of the nineteenth century, the territories of the world open to European exploration and trade had expanded so dramatically that far-off countries became objects not only of curiosity but also of study. A new science – anthropology – was born. In 1882 an anthropological museum opened in Paris. An Exhibition of Central America took place in Madrid in 1893. And in 1898 the French discovered a rich source of tribal art in their West African colony of Benin (called Dahomey from 1899 to 1975).

And so it was that although the first Exhibition of African Art was mounted in Paris only in 1919, young artists had by then already been familiar with African artefacts for quite a while. According to one art-dealer, some of the Parisian artists had fair-sized personal collections from black Africa and Oceania. It is more than possible that the German Expressionist painter Karl Schmidt-Rottluff developed an interest in collecting such items even earlier. His fellow Expressionist Ernst Kirchner claimed that he had 'discovered' black African sculpture back in 1904, in the anthropological museum.

But one event in particular marked a significant stage in the interface between European and African art, in that it presaged the rejuvenation of the former by the latter. The story was later narrated by the artist Maurice de Vlaminck and his friends.

26 A view on Vlaminck's studio: African statues

27 A view on Vlaminck's studio: African statues

Vlaminck was travelling back from doing some sketches up in Argenteuil, to the north-west of Paris, when he decided to stop at a bistro. There, he was surprised to espy – between the racked bottles of Pernod – wooden statuettes and masks, all of which had been brought from Africa by the bistro-proprietor's son. Vlaminck purchased the lot there and then. Once he had got home he showed them to his studio-companion André Derain, who was so impressed that in turn he persuaded his friend to sell them all on to him. Presumably, Derain next took them over to Matisse' studio to show him and the same thing happened yet again, because Picasso was amazed to be shown them when he was invited to dinner specially by Matisse. The story was concluded by Max Jacob, who recounted how he discovered Picasso the next morning poring over a stack of sketch-papers, on each one of which was an increasingly simplified head of a woman.

Vlaminck perceived what was the most valuable point of things 'primitive'. 'Black African art manages by the simplest of means to convey

28 **Henri Matisse**
*An Arabian Cafe*, 1913
Tempera on canvas, 176 x 210 cm
Hermitage, St Petersburg

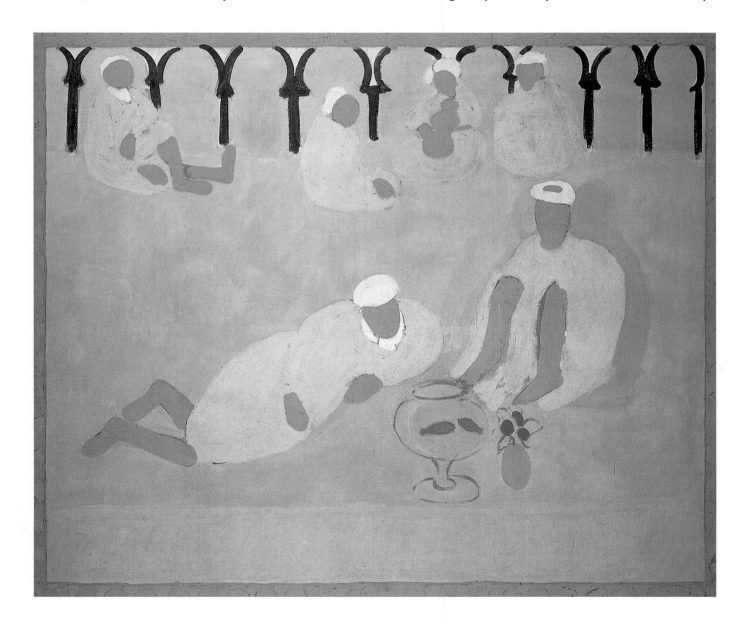

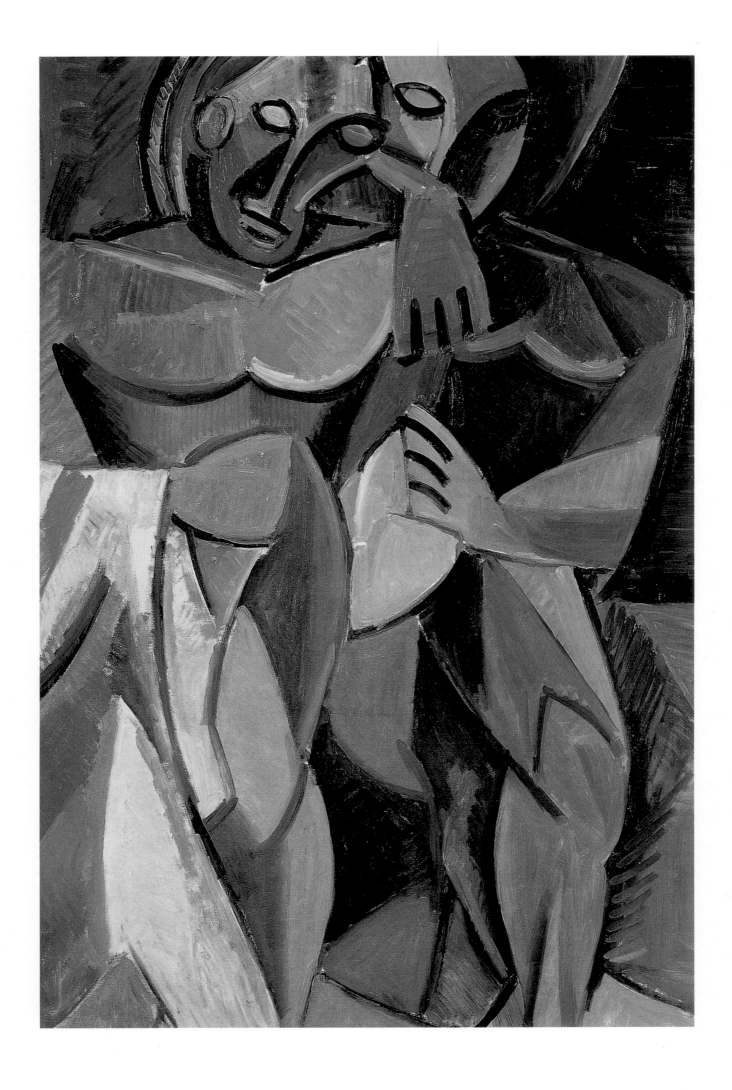

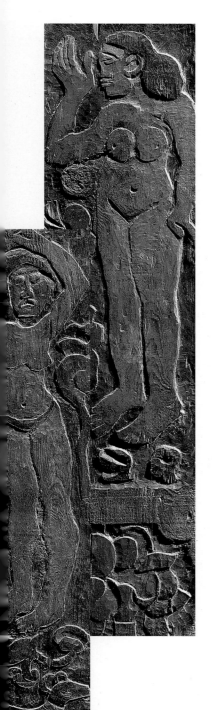

29 **Pablo Picasso**
*Friendship*, sketch, 1908
Watercolours, gouache on paper
61.9 x 47.6 cm
Pushkin Museum

an impression of stateliness but also stillness.'[5] Nonetheless, having passed through the hands of Vlaminck, Derain and Matisse – all of them great artists – African sculpture directly affected only Pablo Picasso. Vlaminck dated this story to 1905, although most likely it actually happened a bit later. In any case, all the artists involved were by then in a mood to accept primitive art as a complete and entire phenomenon, not simply as a mass of individual and multifarious items.

Most significantly, Picasso gradually worked out how to reveal the primal nature of objects thanks to the expressivity of African sculpture. It was this discovery that provided the impetus for him to go on to develop Cubism.

However primitive the sense of form presented by black African sculpture might seem to the European eye, it represented an aesthetic school that was centuries old and a tradition of craftsmanship inherited from remote ancestors. That a system exists means that it is possible to study it, to learn from it and to work to it. This is why the influence of African carving on European art has been so marked during the twentieth century.

Today, then, the art courses of many educational establishments focus on the interrelationship between twentieth-century painting and black African art, together with the influence of the art forms of native North America, Oceania and Arabic/Islamic Africa on European and North American artists from Gauguin up to the Surrealists. As art expert Jean Laude has said, the 'discovery' of black African art by Europeans 'seems to be an integral part of the general process of renewing sources; it is certainly a contributory factor'.[6] It was at the peak of this wave of enthusiasm, at the very moment of 'the decline of the West', that the *naïve* artists emerged. There was no need to go searching for them in Africa or in Oceania.

30 **Paul Gauguin**
Panels for *The House of Pleasure*, 1902
Carved wood, 200 x 160 cm
Musée d'Orsay, Paris

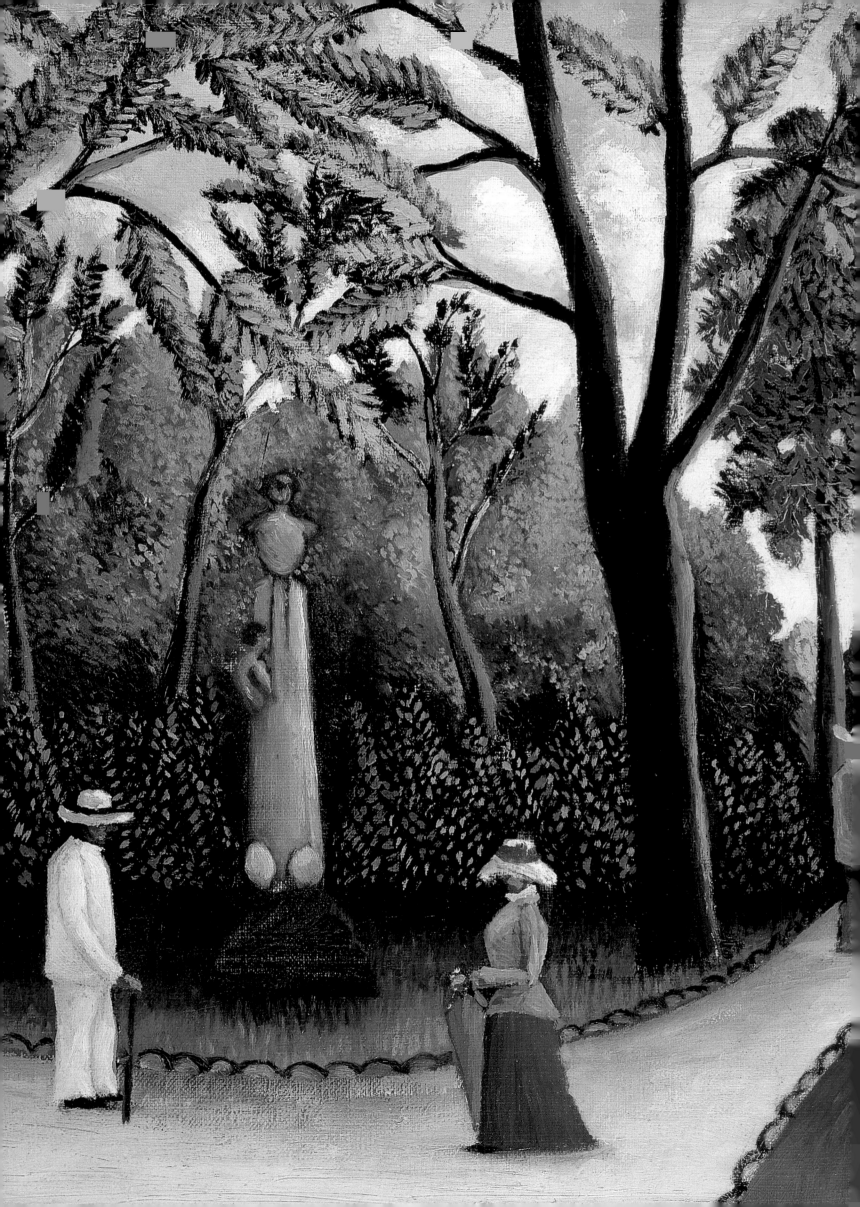

# Discovery – the Banquet in Rousseau's Honour

2

Impressionism actually had more of an effect upon art in general than it initially seemed to. The rebellion against the 'tyranny' of the old and traditional system of Classicism that it fomented – the establishing of the principle of freedom in content, form, style and context – led to a broadening of the whole concept of 'art' itself.

Towards the end of the Impressionist 'period' – so much so that they are forever labelled Post-Impressionist – Paul Gauguin and Vincent van Gogh joined the Impressionists' ranks. What they lacked in training they made up for in hard work. Indeed, only in the very early pictures of Gauguin is any deficiency of skill evident. And when van Gogh arrived in Paris in 1886, no one expressed any doubts as to his worthiness to take his place among the international clique of artists in the community in Montmartre which by that time had existed there for nigh on a century. Perhaps inevitably, the pair did not, however, find acceptance in the *salon* dedicated to the most classical forms of contemporary art. They were nonetheless able to exhibit their works to the public, especially since Parisian art-dealers – *marchands* – were opening more and more galleries. In 1884 the Salon des Indépendants was launched. This had no selection committee and was set up specifically to put on show the works of those artists who painted for a living but were yet unable or unwilling to meet the requirements of the official *salons*. Of course there were many such artists – and of course among the overwhelming multiplicity of their mostly talentless works it was not always easy to identify those pictures that were exceptional in merit.

Henri Rousseau served as a customs officer at the Gate of Vanves in Paris. In his free time he painted, sometimes on commission for his neighbours and sometimes in exchange for food. Year after year from 1886 to 1910 he brought his work to the Salon des Indépendants for display, and year after year his work was exhibited with everybody else's despite its total lack of professional worth. Nevertheless he was proud to be numbered among the city's artists, and thoroughly enjoyed the right

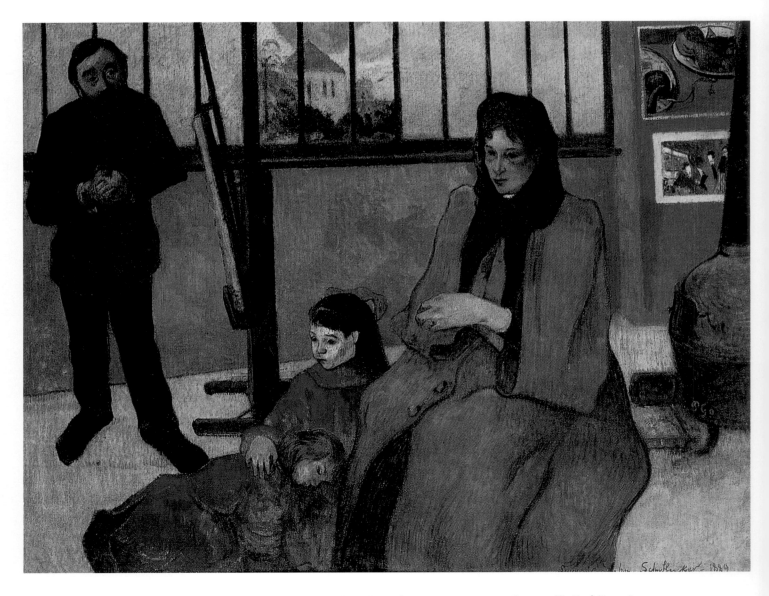

they all had to see their works shown to the public like the more accepted artists in the better *salons*.

       Rousseau was among the first in his generation to perceive the dawn of a new era in art in which it was possible to grasp the notion of freedom – freedom to aspire to be described as an artist irrespective of a specific style of painting or the possession or lack of professional qualifications. His famous picture (now in the National Gallery, Prague), dated 1890 and entitled *Me. Portrait-Landscape.* rather than the comparatively feeble *Self-Portrait*, reflected that selfsame ebullient self-confidence that was a characteristic of his, and established the image of the amateur artist taking his place in the ranks of the professionals. 'His most characteristic feature is that he sports a bushy beard and has for some considerable time remained a member of the Society of the Indépendants in the belief that a creative personality whose ideas soar high above the rest should be granted the right to equally unlimited freedom of self-expression',[7] was what Rousseau wrote about himself in his autobiographical notes.

31 **Paul Gauguin**
*The Schuffenecker Family,*
1889
73 x 92 cm
Musée d'Orsay, Paris

It just so happened that Pablo Picasso visited a M. Soulier's bric-a-brac shop in the Rue des Martyrs on a fairly regular basis: sometimes he managed to sell one of his pictures to M. Soulier. On one such occasion Picasso noticed a strange painting. It could have been mistaken for a pastiche on the type of ceremonial portraits produced by James Tissot or Charles-Émile-Auguste (Carolus-Duran) had it not been for its extraordinary air of seriousness. The face of a rather unattractive woman was depicted with unusually precise detail given to its individual features, yet with a sense of profound respect for the sitter. Somehow the female figure – clothed in an austere costume involving complex folds and creases and surrounded by an amazing panoply of pansies in pots on a balcony, observing a prominent bird flying across a clouded sky, and holding a large twig in one hand – looked for all the world like a photographer's model as posed by an amateur photographer, but still was hauntingly realistic and arresting. The artist was Henri Rousseau. The price was five francs. Picasso bought it and hung it in his studio.

**32 Vincent van Gogh**
*Weaver Seen From Front,*
1884
Oil on canvas, 70 x 85 cm
Rijskmuseum, Amsterdam

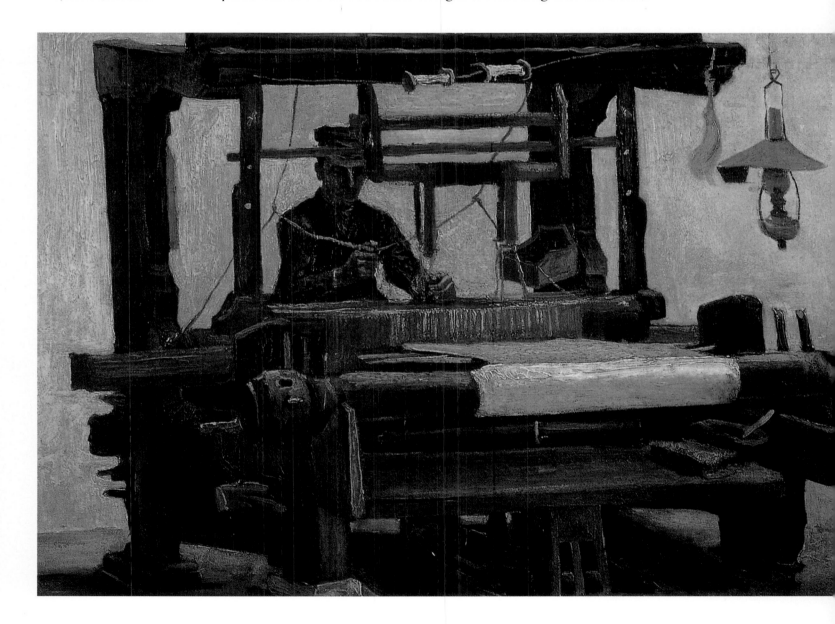

33 **Henri Rousseau**
*Me, Landscape-Portrait*, 1890
Oil on canvas, 143 x 110 cm
Narodni Gallery, Prague

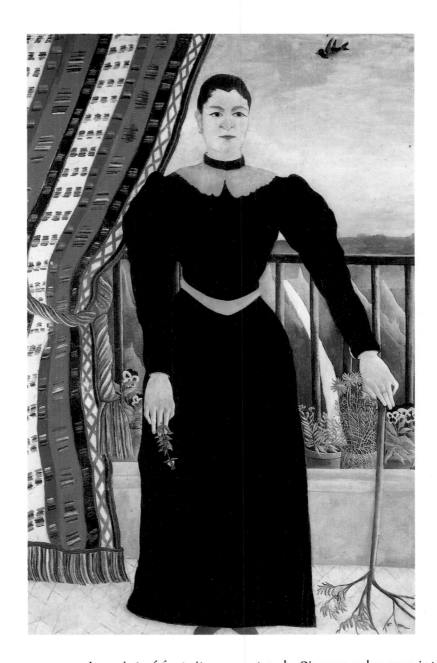

34 **Henri Rousseau**
*A Woman's Portrait*, 1895
Oil on canvas, 160 x 105 cm
Musée du Louvre, Paris

In point of fact, it was not only Picasso who was interested in Rousseau's work at this time. The art-dealer Ambroise Vollard had already purchased some of Rousseau's paintings, and the young artists Sonja and Robert Delaunay were friends of his, as was Wilhelm Uhde, the German art critic who organized Rousseau's first solo exhibition in 1908 (on the premises of a Parisian furniture-dealer). But it was Picasso who, with his friends, decided in that same year to hold a party in Rousseau's honour. It took place in Picasso's studio in the Rue Ravignan at a house called the Bateau-Lavoir. Some thirty people turned up, many of them naturally Picasso's friends and neighbours, but others present included the critic Maurice Raynal and the Americans Leo and Gertrude Stein.

Decades later, during the 1960s, by which time the 'Rousseau banquet' had become something of a legend in itself, one of the guests – the *naïve* artist Manuel Blasco Alarcon, who was Picasso's cousin – painted a picture of the event from memory. Henri Rousseau was depicted

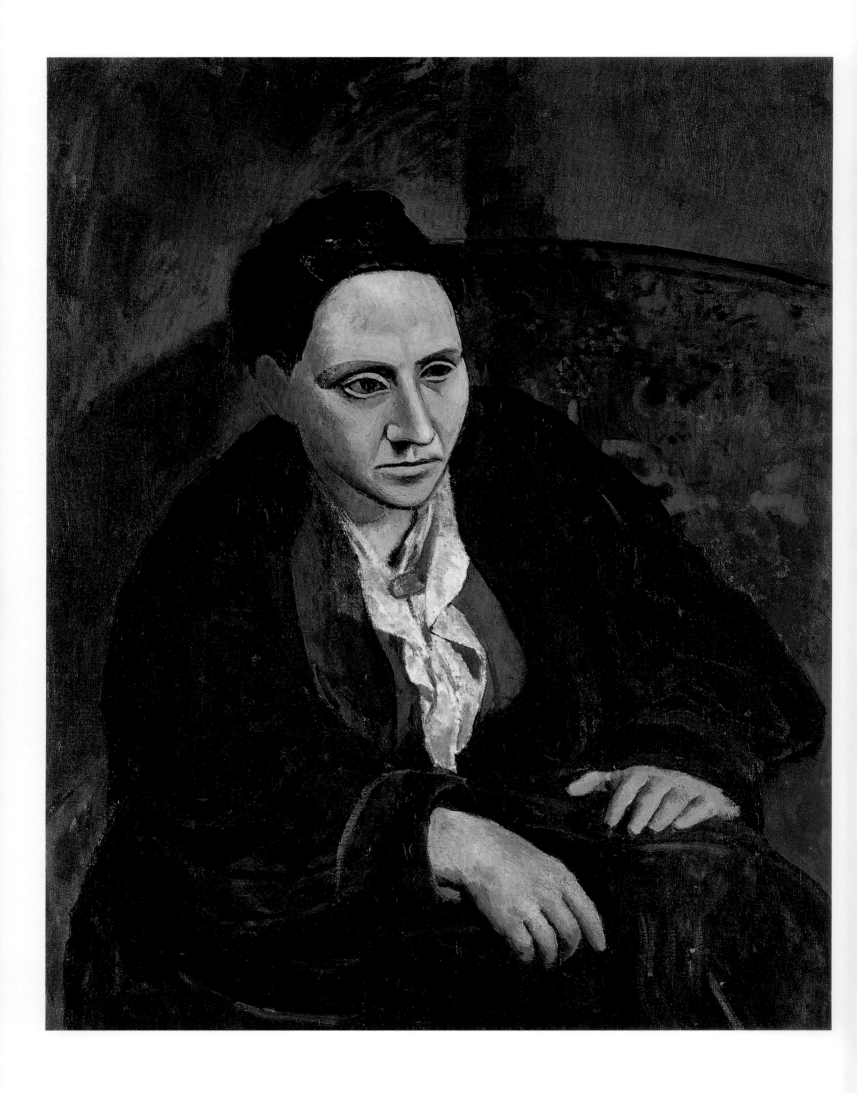

**35 Pablo Picasso**

*Portrait of Gertrude Stein*, 1906

Oil on canvas, 100 x 81 cm

Metropolitan Museum of Art, New York

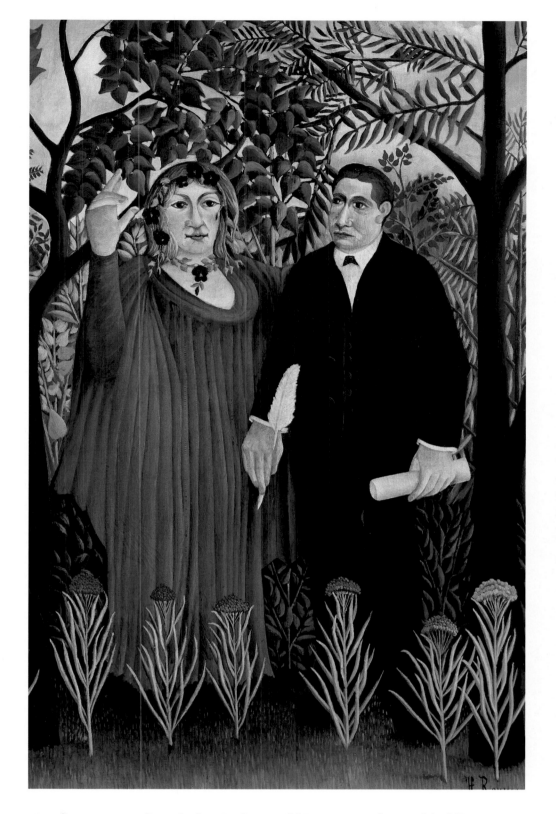

**36 Henri Rousseau**

*Guillaume Apollinaire and Marie Laurencin*, 1909

Oil on canvas, 200 x 389 cm

Hermitage, St Petersburg

standing on a podium in front of one of his own works, and holding a violin. Seated around a table meanwhile were various guests whom Alarcon portrayed in the style of Picasso's *Gertrude Stein* and Henri Rousseau's *Apollinaire* and *Marie Laurencin*.

At the banquet all those years previously, the elderly ex-Douanier Rousseau (then aged 64, having retired from his customs post at the age of 41 in order to concentrate on art) found himself surrounded mainly by vivacious young people intent on having a good

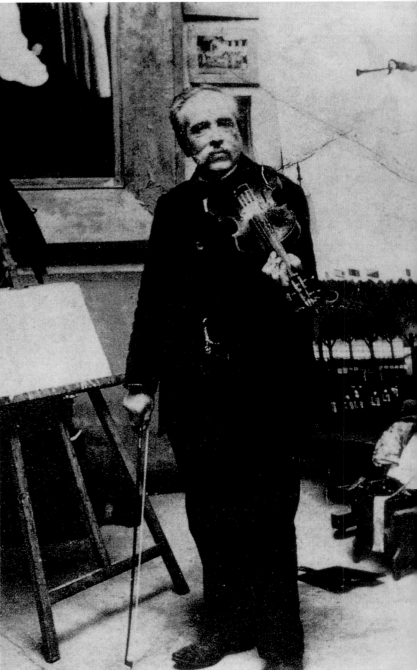

time but in a cultural sort of way. Poems were being recited even as supper was being eaten. There was dancing to the music of George Braque on the accordian and Rousseau on the violin – in fact, Rousseau played a waltz that he had composed himself. The party was still going strong at dawn the next day when Rouseeau, emotional and more than half-asleep, was finally put into a *fiacre* to take him home. (When he got out of the *fiacre*, he left in it all the copies of the poems written for him by Apollinaire and given to him solicitously as a celebratory present.) Even after he had departed, the young people carried straight on with the revels. Only later in the memories of the people who had been there did this 'banquet' stand out in their minds as a truly remarkable occasion. Only then did individual anecdotes about what happened there take on

37  Photograph of Henri Rousseau in his studio

38  Photograph of Wilhelm Uhde

the aspect of the mythical and the magical. Quite a few were to remember a drunken Marie Laurencin falling over on to a selection of scones and pastries. Others indelibly recalled Rousseau's declaration to Picasso that 'We two are the greatest artists of our time – you in the Egyptian *genre* and me in the modern!'[8]

This statement, arrogant as it might have seemed at the time to those who heard it, was by no means as ridiculous as some of those present might have supposed. As the story of the 'Rousseau banquet' spread around the city of Paris and beyond, the people who had been there began in their minds to edit what they had seen and heard in order to present their own versions when asked. Six years later, in 1914, Maurice Raynal narrated his recollections of it in Apollinaire's magazine *Soirées de Paris*. Later still, Fernanda Olivier and Gertrude Stein wrote it up in their respective memoirs. In his *Souvenirs sans fin*, André Salmon went to considerable pains to point out that the 'banquet' was in no way intended as a practical joke at Rousseau's expense, and that – despite suggestions to the contrary – the party was meant utterly sincerely as a celebration of Rousseau's art. Why else, he insisted, would intellectuals like Picasso, Apollinaire and he himself, André Salmon, have gone to the trouble of setting up the banquet in the first place? This was too much for the French artist and sculptor André Derain who publicly riposted to Salmon, 'What is this? A victory for *con-artistry*?'[9] Later, he was sorry for his outburst, particularly in view of the fact that he rather admired Rousseau's work, and only quarrelled with Maurice de Vlaminck, one of his best friends, when Vlaminck was unwise enough to suggest in an interview with a journalist that Derain was dismissive of Rousseau's *oeuvre*.

Only a few years later, and there was actually a squabble about who had 'discovered' Rousseau. The critic Gustave Coquiot in a book entitled *Les Indépendants* expressed his exasperation at hearing people say that it had been Wilhelm Uhde who had introduced Rousseau and his work to the world. How was it, he asked indignantly, that some German fellow could claim in 1908 to present for the first time to the Parisian public a Parisian artist whose work had been on show in Paris to those who wanted to see it ever since 1885 or earlier?[10]

Writing enthusiastically about Rousseau's paintings, and praising his unique style, Coquiot went on to make an interesting comment. 'There must be many an amateur artist in France – Sunday painters who for the rest of the week may be working men, tradesmen or businessmen. I once gave the artist Vlaminck a painting called *Dance of the Bayadère*, produced by a wine merchant from Narbonne. It was a

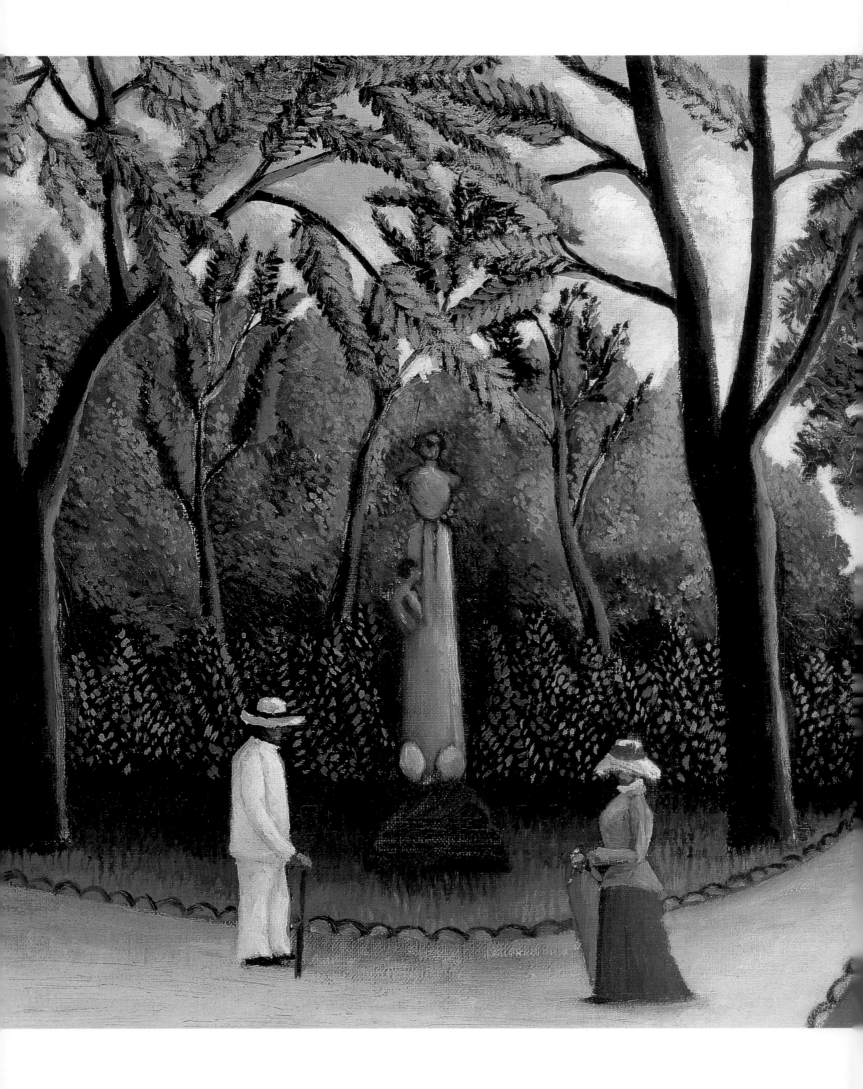

rather pretentious canvas in the style of Rousseau. But the point is that on another occasion the same merchant painted a picture he called *Place de l'Opéra* which did indeed show the Opera in all its intricate detail. Now that is surely amazing!'[11]

These words of Coquiot mark a new line in the spectrum that is the history of *naïve* art. Discussion and appreciation of Rousseau's works inevitably led to discussion and (sometimes) appreciation of the works of others in similar vein. Accordingly, some perhaps not so talented but undoubtedly original artists were noticed and even encouraged to come forward. A chain of 'discoveries' ensued. 'Primitive' and 'naïve' art was suddenly all around – to the extent that professional artists were becoming heavily involved.

**39 Henri Rousseau**
*The Luxembourg Garden*, 1909
Oil on canvas, 38 x 47 cm
Hermitage, St Petersburg

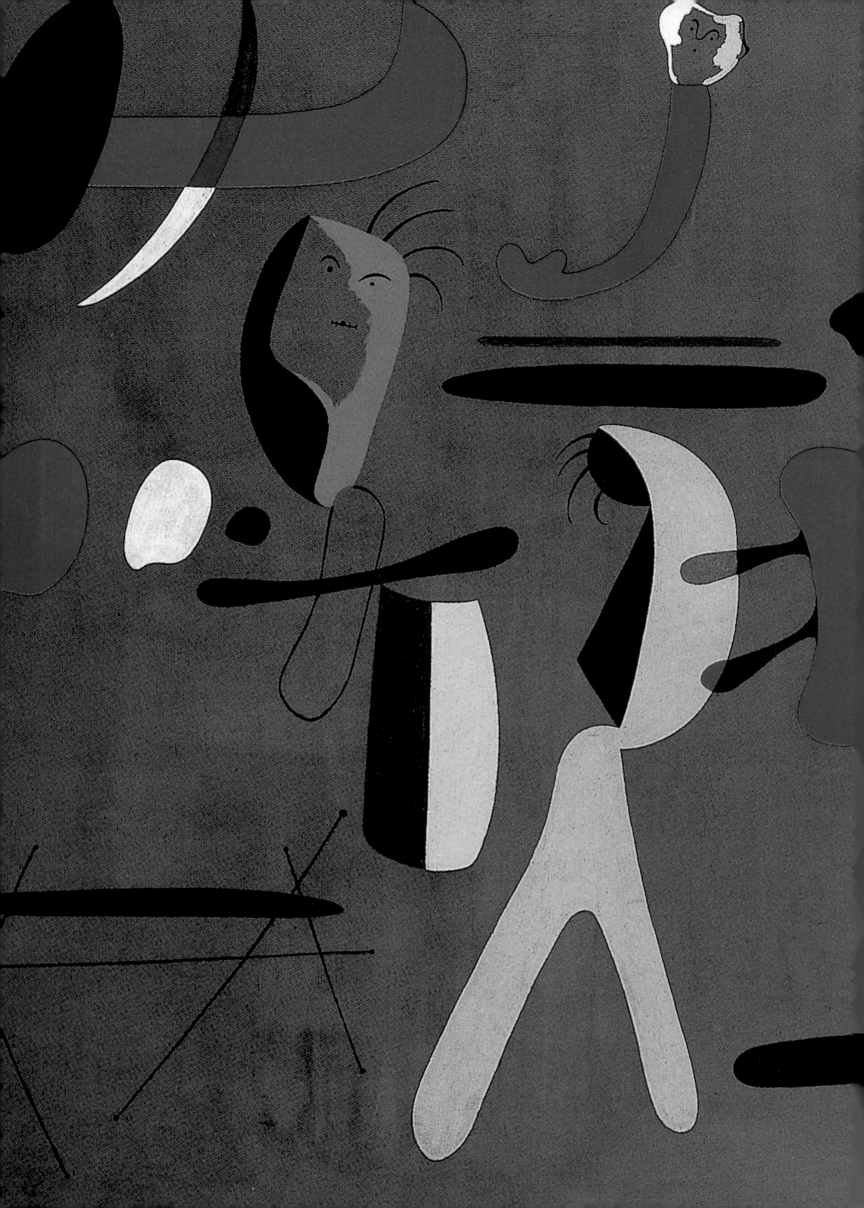

# Modern Fascination with "Primitive" Artists: Joan Miró

<span style="font-size:3em">3</span>

In 1919 Pablo Picasso bought himself a picture by the young Catalan artist Joan Miró. Called *Self-Portrait*, the picture was painted in a way that gave no hint at all that its originator had spent many years studying art. Instead, it resembled the diligent yet clumsy handiwork of an unskilful village artist. And that was what so captivated Picasso. *Self-Portrait* marked the beginning of a friendship between the two men.

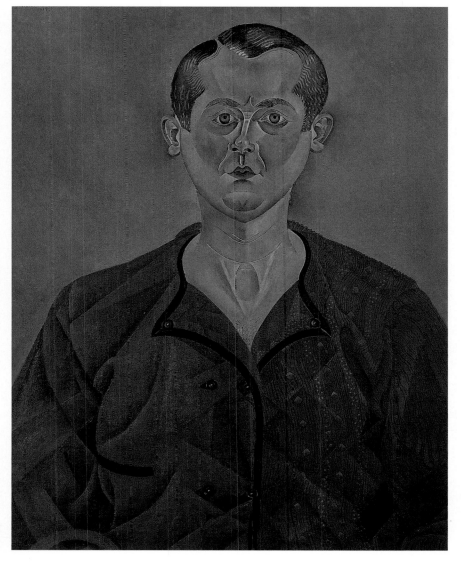

**40 Joan Miró**
*Self-Portrait*, 1919
Oil on canvas, 75 x 60 cm
Private collection, New York

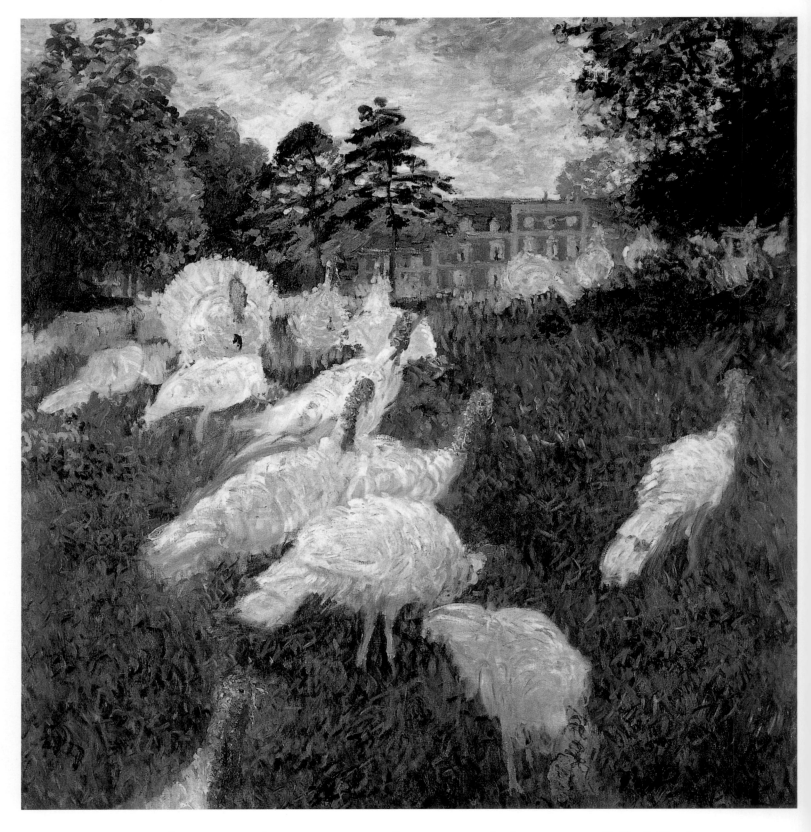

Based in Paris, Miró went on to enjoy the company of other artistic and cultural luminaries, notably Max Ernst and André Masson, the poets Pierre Reverdy, Max Jacob and Tristan Tzara, and the critic Maurice Raynal. The artists of the contemporary Paris school were particularly intrigued by Miró's work, believing that they saw in it the rudiments of a new, lively style that might do much to reinvigorate what they had come to think of as the depressingly indolent state of European art.

41 **Claude Monet**
*Turkeys*, 1877
Oil on canvas, 174.5 x 172.5 cm
Musée d'Orsay, Paris

This, after all, was only a decade or so after the end of the nineteenth century - a time when artists, in despair at the superficiality and falseness of civilized society, had turned their eyes more towards primitive communities of 'natives' and 'savages'. Paul Gauguin, for one, left France altogether in order to try to experience oneness with nature among the people of the Pacific islands, thousands of miles from the soaring cities of his homeland. His intention was to immerse himself in the life and culture of Tahiti in such a way as to reinvent his own artistic style, firmly believing that in their roughly-carved stone idols the Tahitian

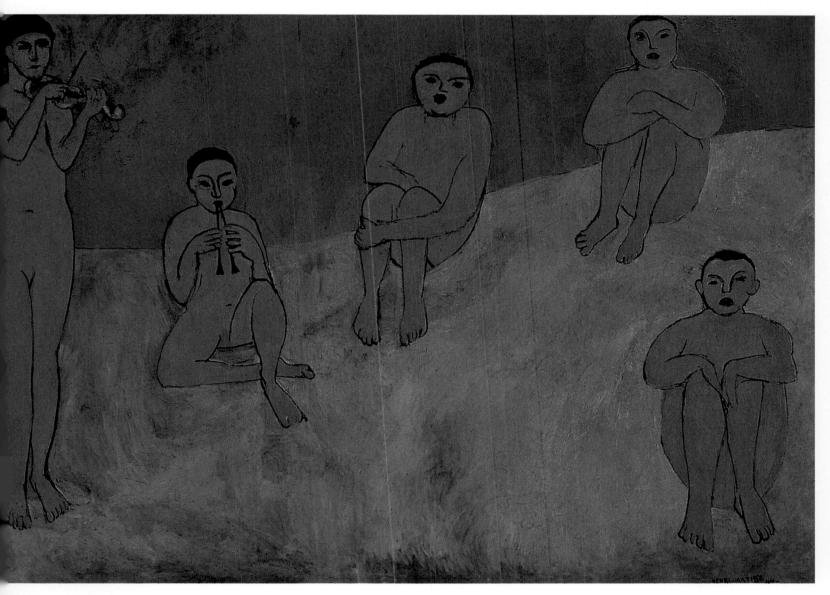

**42 Henri Matisse**
*The Music,* 1910
Oil on canvas, 260 x 389 cm
Hermitage, St Petersburg

sculptors were able somehow to express what was beyond the capacities of the more polished art of European studios.

By the time Joan Miró arrived in Paris, however, the young Catalan had already found sources of inspiration much closer to home.

Miró was born in Barcelona in April, 1893. Brought up in the city, he specialized in drawing from an early age and attended various art schools there, learning the standard methods of drawing and painting. Art

exhibitions were frequent, and Miró took a particular interest in works by Parisian artists - from the Impressionists to Matisse - that were on view from time to time. During this period, most of his holidays from school were spent with his maternal grandparents in Palma de Mallorca, the capital of Majorca. Now on the cliffs of Majorca there remain a number of prehistoric paintings and drawings which, in their skilful use of the expressive dynamism of empty space, succeed not only in communicating a distinctive perception of the world but in conveying - through strength of form - the very human sense of pride in power. Joan Miró visited Majorca repeatedly through his life. And it would seem likely that each time he did so, it was consciously or unconsciously to reaffirm his attraction for such large simple forms, for such clean lines and for such natural texture of material.

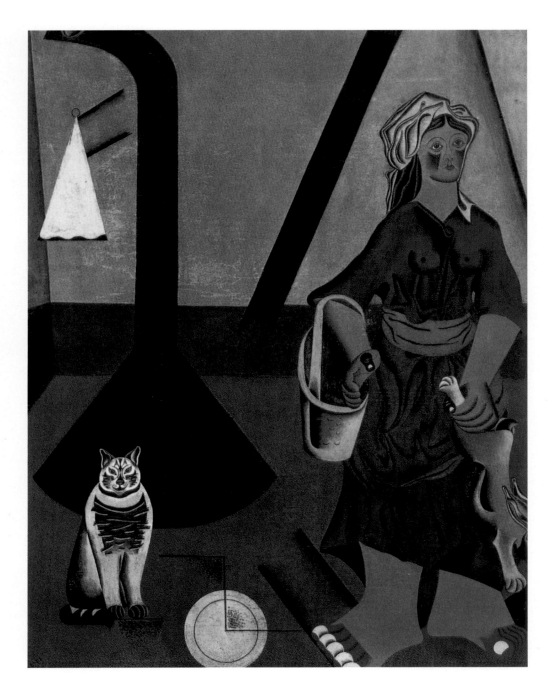

43 **Joan Miró**
*The Farmer's Wife*, 1922-1923
Oil on canvas, 81 x 65 cm
Collection of Mrs Marcel Duchamp, New York

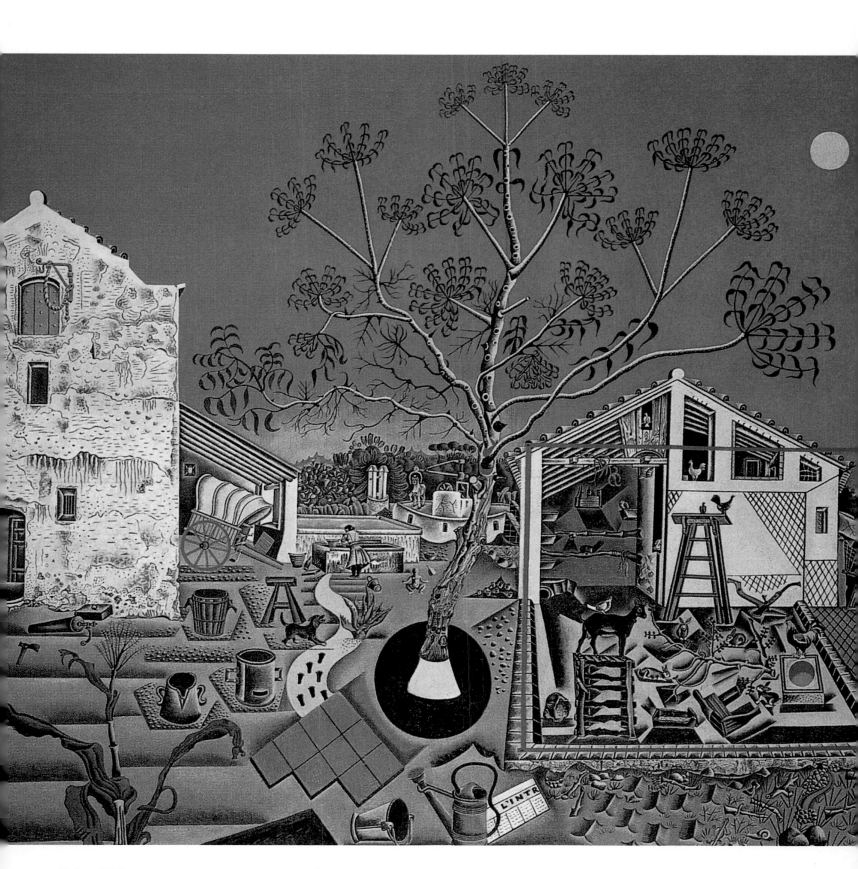

**44 Joan Miró**
*The Farm, 1921-22 in Montroig*
Oil on canvas, 132 x 147 cm
National Gallery, Washington DC

There were, however, additional sources of inspiration for these facets of Miró's art. The son of a jeweller-watchmaker and grandson of a cabinet-maker, Miró was brought up to appreciate and respect craftsmanship. When he was 18 years old, his parents bought a house out in the countryside near a village called Monroi which became one of his favourite hideaways for working and relaxing in. It is quite probable that this closeness to the culture and art of rural life had a formative influence

on his later involvement with ceramics, and more than possible too that the folk-motifs of plants and animals painted on village jugs and plates distilled in his paintings into the simplified figures of horses and bulls for which he became renowned. The simple artefacts of everyday rural life, roughly made and roughly decorated, caused him to look with increasing attention at the minutiae of life around him. 'I'll tell you what interests me more than anything else,' he said. ' It is the linear form of a tree or a roofing-tile - it is gazing at one leaf after another, one twig after another, one clump of grass after another…'[12] Just as probable is that this passion

**45 Joan Miró**
*Painting*, 1933
Oil on canvas, 130.4 x 162.5 cm
Joan Miró Foundation, Barcelona

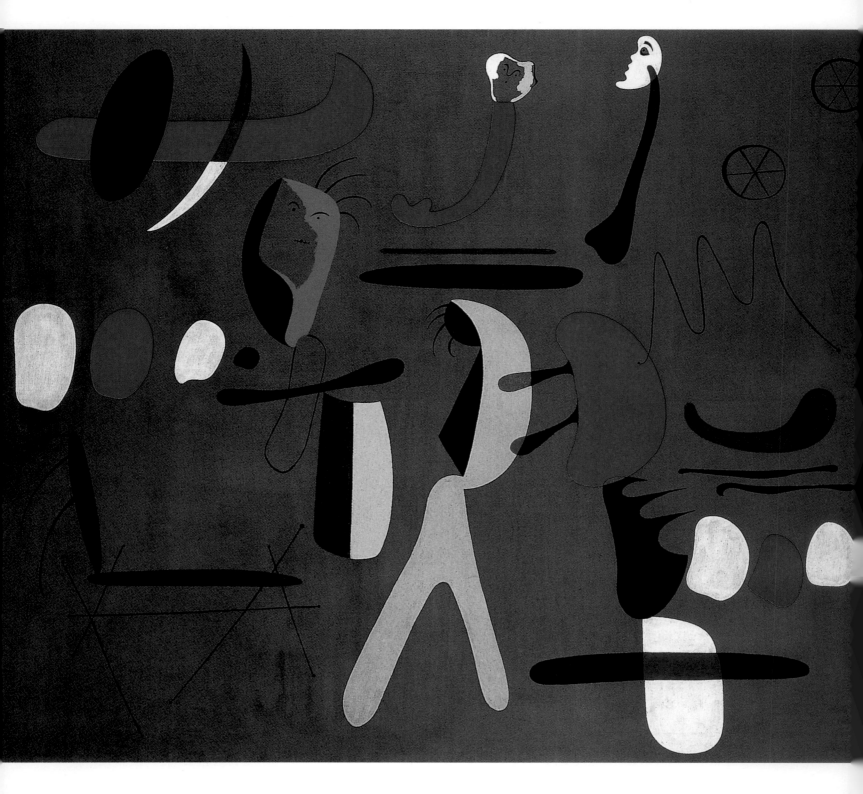

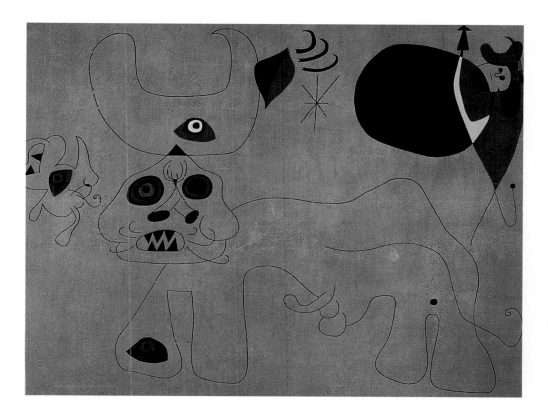

**46 Joan Miró**

*The Bulls' Race,* 1945

Oil on canvas, 114 x 145 cm

Museum of Modern Art, Centre
Georges Pompidou, Paris

was aroused in him by the paintings that he saw throughout his youth in
the churches of Catalonia and the Balearic Islands. For the most part
these churches were decorated with paintings featuring scenes from the
Bible lovingly produced by artists who belonged to that period during the
Middle Ages when every element of nature was deemed worthy of
attention. Even in the second decade of the twentieth century such artists
were described as 'primitives'.

Following an upbringing that both fortuitously and fortunately
brought him into contact with artistic ideas of bygone centuries -
prehistoric, medieval and folk-rural - Miró was able as a mature,
professional artist to incorporate something of their dynamic into his
work. In this way he embodied a source of fresh artistic energy which his
generation had been seeking for some time. Its effect on his own work
was extraordinary. His paintings gradually focused less on representation
and more on colour and essential form, with a strong sense of humour
and a liking for curves.

In other words, his pictures took on the properties of the
so-called *naïve* artists' who were to burst upon the western European art
scene and to become perhaps the greatest sensation of twentieth-century
art.

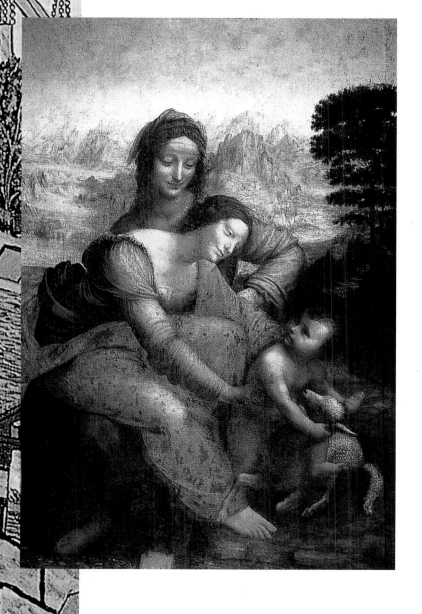

# From Medieval to Naïve Artists: A Similar Approach?

'Primitive' art may on first consideration seem to bear little relevance to a review of *naïve* art. But there is a connection. It was the energy of this primitive stratum of art which nurtured every *naïve* artist of the twentieth century. More significantly, the *naïve* artists were rescued from their obscurity on the crest of a wave of enthusiasm for all things 'primitive' and all things 'wrong' which had no ties to any specific geographical or

**47 Leonardo da Vinci**
*The Virgin Mary, Jesus as a Child and Saint Anne*, ca 1510
Wood, 168 x 112 cm
Musée du Louvre, Paris

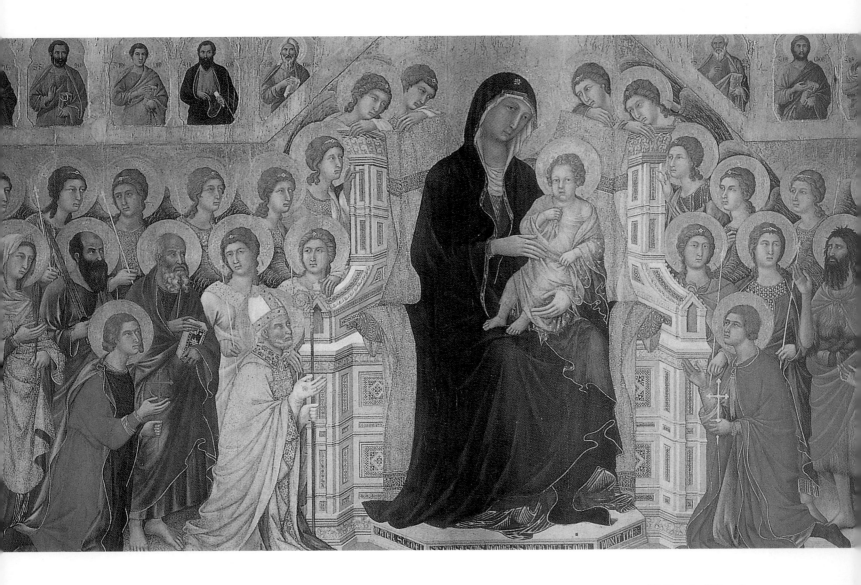

chronological framework. The first stirrings of the swell that was to
produce that wave of interest had come centuries earlier, during the Age
of Romance.

The Renaissance in Europe relied on a scientific system of
pictorial representation that remained the sole criterion of the professional
artist until the twentieth century. 'A mirror that has a flat surface
nonetheless contains a true [three-dimensional] picture on this surface. A
perfect picture executed on the surface of some flat material should
resemble the image in the mirror. Painters, you must therefore think of the
mirror's image as your teacher, your guide to chiaroscuro and your
mentor for the correct sizing of each object in the picture,' wrote Leonardo
da Vinci.[13] So rejecting everything that had to do with the realm of
sensitivity and intuitive insight, the Renaissance artist revered scientific
measurement and precision to such an extent that painting was
thoroughly enmeshed in a network of mathematical calculations. Art had
indeed become a science.

To the Renaissance artist, all other forms of artistic endeavour –
prehistoric art, the art of the early inhabitants of Africa and Oceania, the

48 **Duccio di Buoninsegna**
*Maestà (altar)*, 1311
Tempera on wood, 214 x 412 cm
(central panel)
Original size of the retable:
around 500 x 468 cm
Museo dell'Opera del Duomo,
Sienna

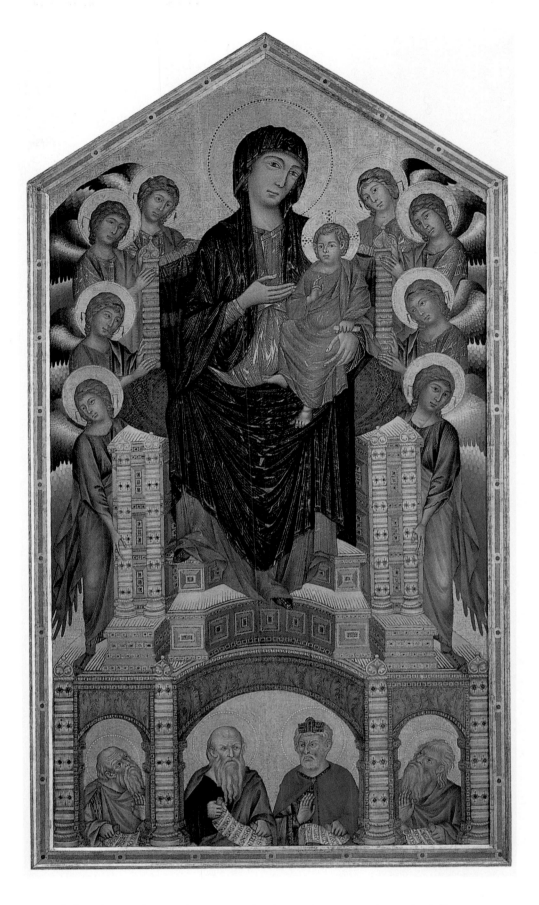

**49 Cimabue**

*Madonna on her Throne (Madonna of Santa Trinita),* 1280-1285

Tempera on wood, 385 x 223 cm

Galeria degli Uffizi, Florence

art of the Oriental peoples, even the homely crafts of rustic fellow Europeans – remained outside the limits of what was true art. The whole body of artistic enterprise that had accumulated during the Middle Ages (with all its cathedrals and religious masterpieces) was similarly not to be regarded as true art. No heed was paid to the fact that the medieval artists genuinely did work to a system – their own contemporary system.

**50 Jan van Eyck**
*Crucifixion*, 15th century
(detail)

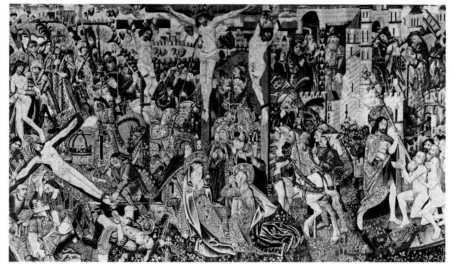

**51** Tapestry from Angers.
Panel of the passion.
*The Crucifixion*

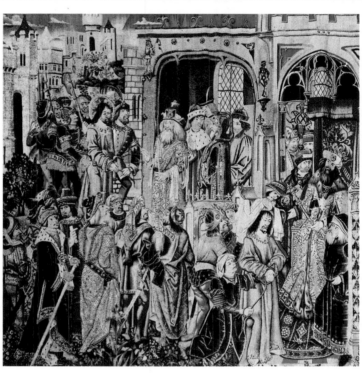

**52** Tapestry from Angers.
Panel of the passion.
*The Sentencing of Jesus*

The logic went that they were 'primitive' because, principally, they did not profess the religion of perspective. Duccio di Buoninsegna, Cimabue and Giotto – great masters of the thirteenth and fourteenth centuries – were all 'primitives' because their paintings did not present a scientifically-proportioned mirror-image of reality.

The Age of Romance marked the beginning of a reconciliation with the 'primitives', the first steps on a return journey. It was not an end in itself for the young Romantic artists. They rejected the traditional classical subjects of paintings, based on Plutarch's *Lives*, demanding that art become more closely related to reality and contemporary life. The critic Jal wrote in 1824, 'I have been a citizen of Athens, of Carthage and of Latium. Today, what I want is France.'¹² All very well, of course, but France would not be France today without the France of yesterday: the past is an intrinsic part of the present.

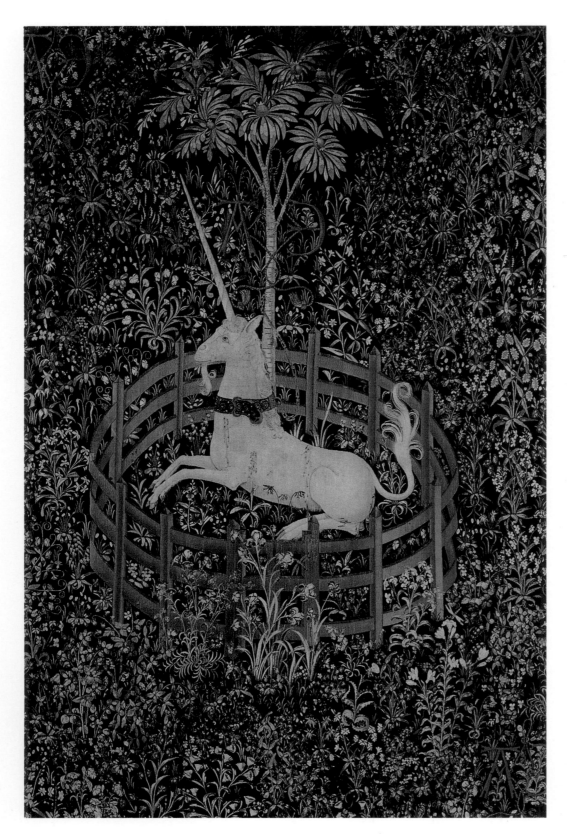

53  Tapestry (7th part),
*The Captured Unicorn*
The Cloisters, Metropolitan
Museum of Arts, New York

It was in 1831 that Victor Hugo astounded the world with his
presentation in a novel of a Paris completely different from the city of his
contemporaries. The book in which he brought it all to life is in English
called *The Hunchback of Notre Dame* (although the French title is the
slightly more prosaic *Notre-Dame de Paris*), and the Paris he portrayed –
specifically the area of Paris known as Notre Dame – was one that few
nineteenth-century Parisians had thought seriously about. 'However

beautiful the modern Paris might seem to you,' wrote Hugo to his readers, 'replace it with the Paris of the fifteenth century. Reproduce it in your imagination. Look at the world anew through an extraordinary forest of spires, turrets and steeples...[15] 'At that time it was a city of two levels,

**54 André Duranton**
*Notre-Dame de Paris*

Romanesque and Gothic.'[16] This was the first occasion in recorded history that a notable commentator was viewing the changes in architecture wrought by the Renaissance as a crime perpetrated on its original, true appearance. 'The Renaissance era turned out to be intolerant. Not satisfied with creating, it wanted to overturn things.'[17] With the fervour of a true Romantic, Hugo railed at previous generations for allowing the grandly mysterious, majestic area of the city to become the travesty of an eyesore it now was. 'Such maiming and dismembering, such wholesale changes to the very nature of a building, such perverse "restoration" work – these are the kinds of things done by the followers of Vitruvius and Vignola [writers of the standard textbooks on systematic order in classical architecture]!' he thundered.[18]

Not content with pouring scorn on the 'new order', Hugo was fulsome in his praise for the 'primitives'. 'This is how magnificent art created by men who cared nothing about what other people thought was

55 **Miguel Garcia Vivancos**
*The Banks of the River Seine,*
1957

56 **Michel Delacroix**
*Notre-Dame Under Snow*

59 (see pages 64–5)
**Henri Rousseau**
*View From the Bridge of
Sevres and the Hills of
Clamart and Bellevue,* 1908
Oil on canvas, 80 x 120 cm
Pushkin Museum of Fine Arts,
Moscow

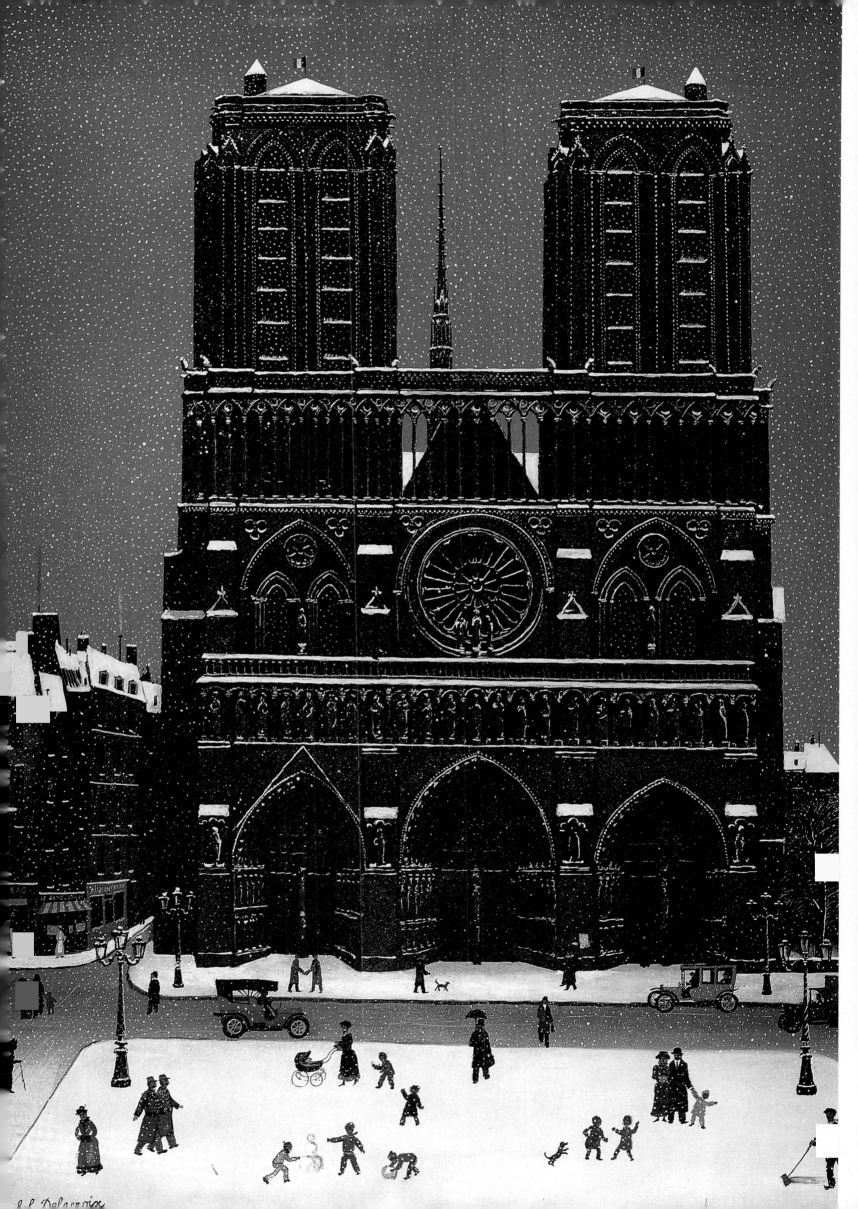

L.P. Delacroix

destroyed by academics and theorists and line-drawers,' he said scathingly,[19] then going on to describe the 'magnificent art'. 'It is like a huge symphony in stone, a vast work of creative endeavour on the part of humankind . . . It is the miraculous result of the combined forces of an entire age, a result by which the energy of a worker influenced by the genius of art bursts forth from every stone, assuming hundreds of forms.'[20] The 'worker' he was talking about was a 'naïve' artist.

The impact Hugo's words made on others of his generation was tremendous. Many immediately determined to defend and protect national treasures that had till then been altogether excluded from the lists and catalogues of artistic works. The architect Eugène Viollet-le-Duc devoted his life thereafter to the accurate restoration of Gothic cathedrals to their original appearance. The writer and playwright Prosper Mérimée, who in his other professional life was Inspector of Historic Monuments, was likewise energetic in seeing to the protection and conservation of medieval works of art, notably *mille-fleurs* tapestries. Thanks to him the Musée de Cluny in Paris came into possession of the magnificent *Lady and the Unicorn* series of tapestries now famous the world over. And from then on, museums and collections in France began deliberately to acquire and display the works of the previously-ignored 'primitives'.

57 **Maurice de Vlaminck**
*untitled*
Oil on canvas, 73 x 92 cm
Hermitage, St Petersburg

**58 André Derain**
*A Harbor in Provence*, 1913
Oil on canvas, 141 x 90 cm
Hermitage, St Petersburg

In due course, an exhibition of medieval French art was staged in Paris in 1904. It brought the world of the 'primitives' to the next generation of artists – to Picasso and Matisse, to Vlaminck and Derain, to the very people who were a few years later themselves to introduce Henri Rousseau to the artistic community.

# From Popular Tradition to Photography

<div style="text-align: right">5</div>

## *Naïve* Artists and Folk Art

A *naïve* artist creates singular and inimitable works of art. This is because, for the most part, the *naïve* artist is not a professional artist but has a quite separate occupation by which he or she earns a living, in which he or she relies on a totally different set of skills (in which he or she may be expert enough to achieve considerable job satisfaction), and which takes up much of his or her daily life. The twentieth century has seen many a 'Sunday artist' who has attracted imitators and patrons but who has never ceased to look at the world through the eyes of his or her workaday occupation. Particularly characteristic of them is an artisan's diligence and pride in the works of art they produce. They are taking their 'professional' attitude towards their workaday occupation and transferring it on to their creations. They have no access to elite artistic circles, and would not be accepted by them if they had. The *naïve* artists thus live in a small world, often a provincial world, a world that has its own artisans - the producers of folk art.

Some say that folk artists have for centuries repeated the same forms using the same colours in the same style, and are doomed therefore endlessly to reproduce the same subjects in their art and to the same standards. But folk artists do not only produce traditional forms of applied art - they also make shop-signs and colourfully ornate panels for stalls and rides at fairs. And although these artisans' work is rooted in their own form of expertise, it is often very difficult to draw a distinct line to separate their work from that of *naïve* artists. Sometimes, after all, the power in the coloration, the sense of modernity and the feel for line and form in an artisan-made sign can elevate it to the level of an outstanding and individual work of art. At the same time it should be remembered that when Henri Rousseau or Niko Pirosmani painted a restaurant sign or was commissioned by neighbours to depict a wedding in their house or their new cart in the barn, the resultant piece would be considered by all to be an artisan's work.

In Russia, the painted sign has always enjoyed a special status, and those who are exceptionally talented at producing them deserve recognition as genuine *naïve* artists. 'A sign in Russia has no equivalent in Western cultures,' wrote the artist David Burliuk in 1913. 'The utter illiteracy of our people [and he was being quite serious at the time] has made it an absolute necessity as a means of communication between shopkeeper and customer. In the Russian sign the folk genius for painting has found its only outlet.'[21] A multitude of    bylaws and regulations governed the size and shape and even the look of signs in urban

60 **Niko Pirosmani**
*Sign For a Wineshop*
Oil on tin plate, 57 x 140 cm
Georgian Museum of Fine Arts, Tbilisi

environments. It was the invenive capacity of the creators that helped
them find a way through the maze of restrictions. By the end of the
nineteenth century the best of the sign-painters were putting their names
to their works: one or two were even making a reputation for themselves.

At the turn of the twentieth century one name that became well
known in St Petersburg in this way was that of Konstantin Grushin. His
work on behalf of the shopkeepers of the city included magnificent
still-lifes of fruit and vegetables, and picturesque landscapes with bulls or
birds.

**61** Konstantin Grushin's studio
*Sign For a Fruit, Vegetable and Poultry Warehouse*, 1st quarter of the XXth century
Oil on burnished iron, 204 x 135 cm
History Museum, St Petersburg

**62** Konstantin Grushin's studio
*Sign For a Fruit, Vegetable, and Poultry Warehouse*, 1st quarter of the XXth century
Oil on burnished iron, 205 x 130 cm
History Museum, St Petersburg

**63 Yevfimy Ivanov**
*Sign For a Butcher's Shop*, 1st quarter of the XXth century
Oil on burnished iron, 248 x 58 cm
History Museum, St Petersburg

**64 Yevfimy Ivanov**
*Sign For a Butcher's Shop*, 1st quarter of the XXth century
Oil on burnished iron, 249 x 97 cm

**65 Konstantin Filipov**
*Sign For a Readymade Clothing Shop*, 1910's
Oil on burnished iron, 220 x 71 cm
History Museum, St Petersburg

**66 Konstantin Filipov**
*Sign For a Tavern*, 1st quarter
of the XXth century
Oil on burnished iron, 213 x 93 cm
History Museum, St Petersburg

**67 Henri Rousseau**
*Father Juniet's Carriage*, 1908
Oil on canvas, 97 x 129 cm
Musée de l'Orangerie, Paris

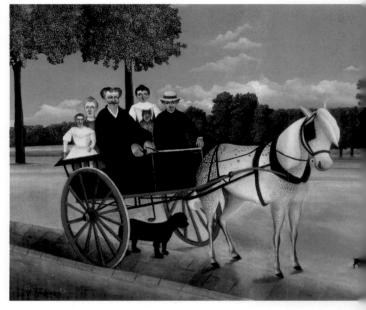

**68 Vasily Stepanov**
*Sign For a Readymade
Clothing Shop Owned by
F. Kuzmin*, 1st quarter of the
XXth century
Oil on burnished iron, 213 x 71 cm
History Museum, St Petersburg

**69 Vasily Stepanov**
*Sign For a Readymade
Clothing Shop Owned by
F. Kuzmin*, 1st quarter of the
century
Oil on burnished iron, 214 x 87 cm
History Museum, St Petersburg

**70 Vasily Stepanov**
*Sign For a Readymade
Clothing Shop*, 1st quarter of
the century
Oil on burnished iron, 213 x 72 cm
History Museum, St Petersburg

Signs were supposed to be painted against a black border. Despite this regulation, the painter Yevfimiy Ivanov managed to produce works of art that truly befitted such a description. His style was free and broad, his composition uninhibited yet expert. Notwithstanding the fact that the functional nature of signs imposed upon them a certain need for a quality of flatness and ornamentation, each artist dealt with this requirement in his or her own way. A panel meant to advertise Shabarshin's Furniture Delivery Services, for example, painted by the talented Konstantin Filippov, may be called a sign only because there are words on it. In all other respects it is an easel-painting. Powerfully-portrayed draught-horses are set against a delicately refined backdrop. The wheels and harnesses of the horses are meticulously executed. In overall style this work is typical of urban *naïve* artists, reminiscent of the famous *Carriage of M. Juniets* by Henri Rousseau.

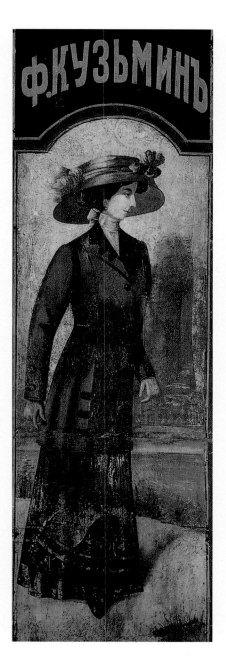 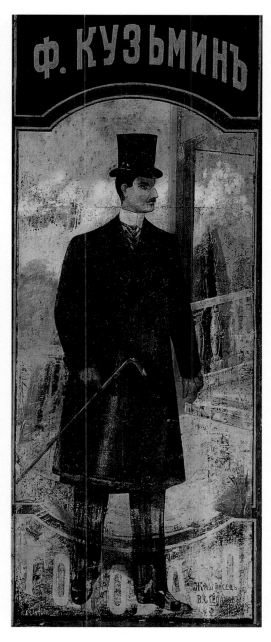 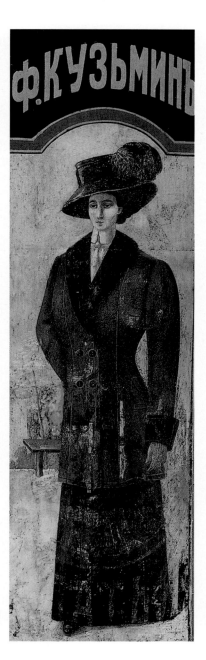

Ready-to-wear clothes shops were particularly blessed in the quality of their signs. Vasily Stepanov's advertising signs for the shops of a certain Mr Kuzmin featured fashionably-dressed ladies and gentlemen, but he made them look as if they had been asked to sit for ceremonial portraits, virtually in *salon* style. Stepanov did, however, include some elements of parody. Singular in themselves and yet typical of their kind, these signs were supremely representative of their time and their location, and as such constitute a sort of historical document.

71 **Mikhail Larionov**
*A Girl at Hairdresser's*, 1920's
Oil on canvas, 159 x 152 cm
From the former collection of
Tomilia Larionova, Paris

72 **Mikhail Larionov**
*A Waitress*, 1911
Oil on canvas, 102 x 70 cm
Tretyakov Gallery, Moscow

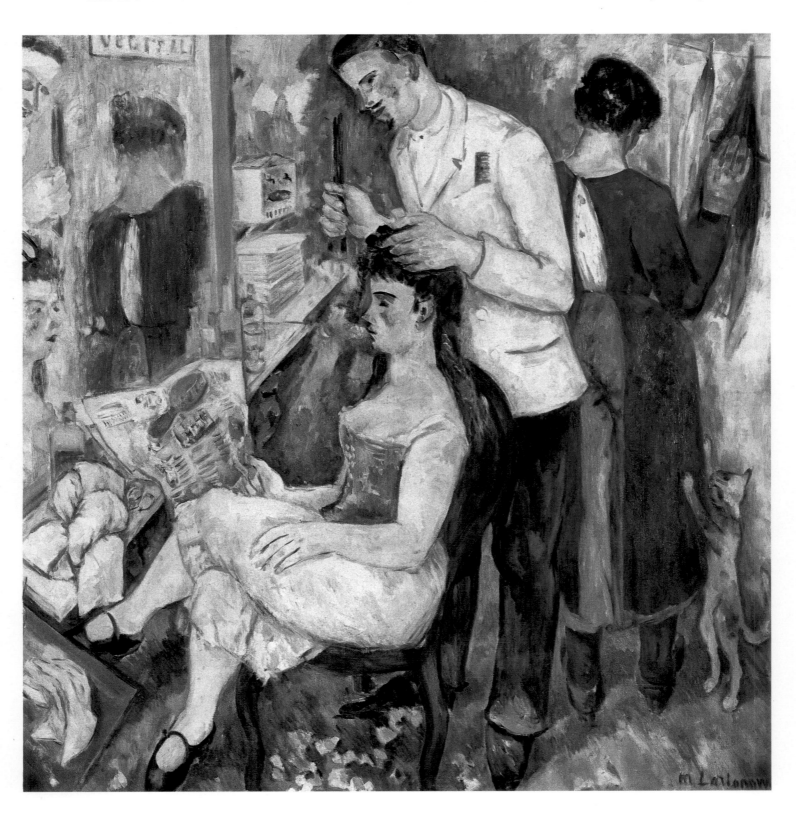

73 **Natalia Gontcharova**
*At Table*, 1914
Sketch for the unmade curtain of
Rimsky Korsakov's opera

It was no wonder that signs like these were prized so highly by the artists of the Russian avant-garde - the artists of Picasso's generation - that they started to collect them. The poet Benedikt Livshitz wrote, 'A burning desire for things primitive, and especially for the signs painted to advertise provincial establishments of such trades as laundry, hair-dressing, and so on - as had had a profound effect on Larionov, Goncharova and Chagall - caused Burliuk to spend all the money he had on buying signs created by artisans . . . For Burliuk it was not simply a matter of satiating a temporary whim involving a fad for folk art, a sudden craze for the primitive in all its manifestations, such as the art of Polynesia or ancient Mexico. No, this enthusiasm was far more profound.'22

**74 Marc Chagall**
*The bathing of the kids*, 1916
Tempora on cardboard, 59 x 61 cm
Art and architecture history
Museum, Pskov

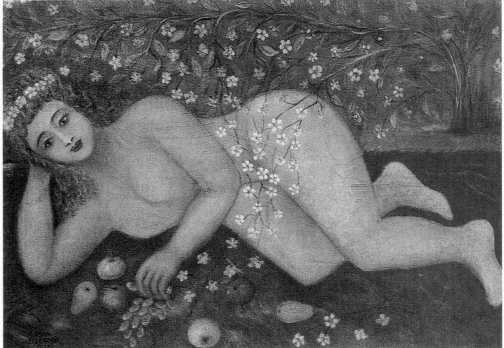

**75  Elena A. Volkova**
*Folk Party by the River Irtich*

**76  Elena A. Volkova**
*A Maiden From Siberia*

**79** (see pages 82–3)
**Boris Kustodiev**
*A Tavern in Moscow*, 1916
Oil on canvas, 99.3 x 129.3 cm
Tretyakov Gallery, Moscow

**80** (see pages 84–5)
**Vassily Kandinsky**
*Imatra*, 1917
Watercolor on paper,
22.9 x 28.9 cm
Pushkin Museum of Fine Arts,
Moscow

**77 Elena A. Volkova**
*Self-Portrait*

**78 Jean-Louis Sénatus**
*Haitian Landscape*

Reflecting on the origins of the interest of the avant-garde in primitive art as a whole, Livshitz quoted an eloquent statement by the brothers David and Vladimir Burliuk. 'There has been no progress whatsoever in art - has been none, and never will be any! Etruscan statues of the gods are in no way inferior to those of [the ancient Athenian] Phidias. Each era has the right to believe that it initiates a Renaissance.'[23]

Historical circumstances delayed the onset of the industrial revolution in Russia. The chaos that surrounded the political Revolution hindered the authorities from re-establishing order in urban centres for some considerable time. Nevertheless, the production of the traditional shop-signs continued for a while not only in rural areas but also in St Petersburg and in Moscow. The German philosopher and diarist Walter Benjamin, who endeavoured to create a written 'portrait' of contemporary Moscow, inscribed in his diary on 13 December 1926, 'Here, just as in Riga, they have wonderful painted signs - shoes falling out of a basket, a Pomeranian [Spitz dog] running off with a sandal between his jaws. In front of one Turkish restaurant there are two signs set like a diptych featuring a picture of gentlemen wearing fezzes with crescents on them sitting at a laid table.'[24]

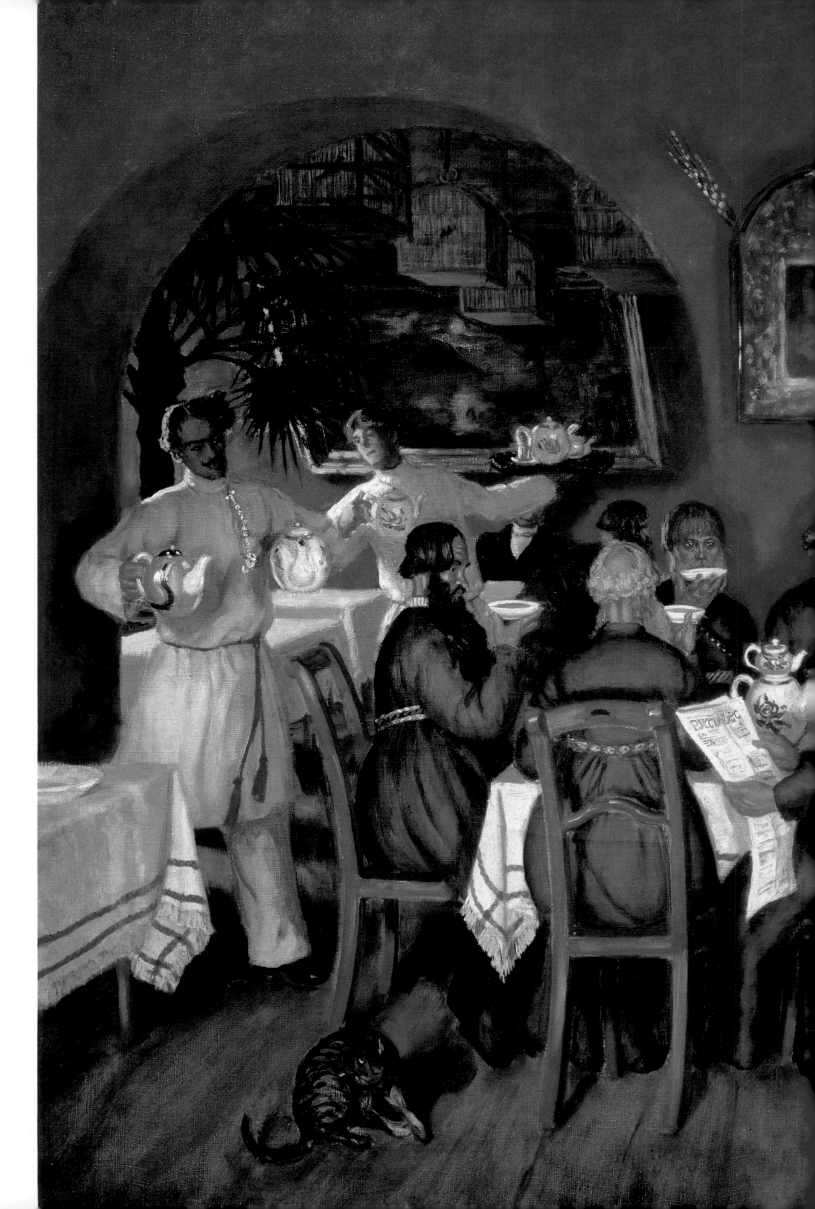

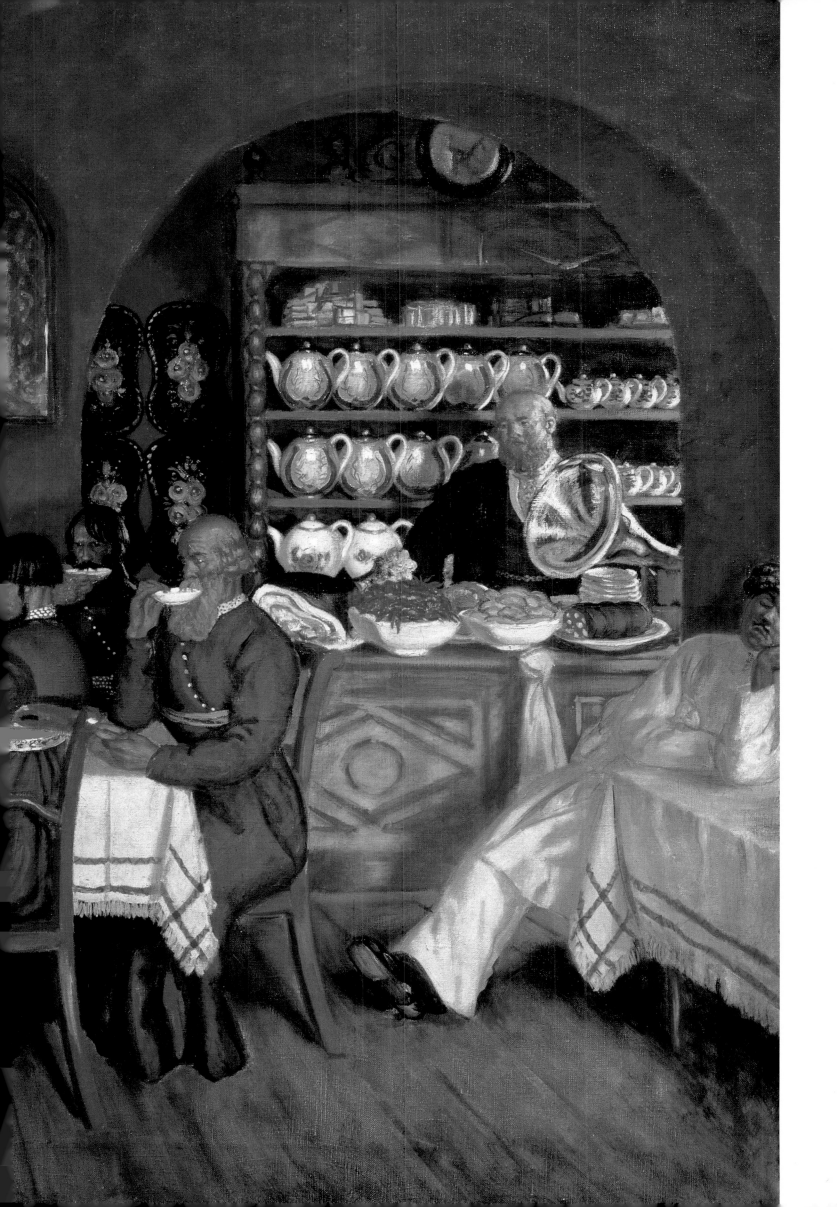

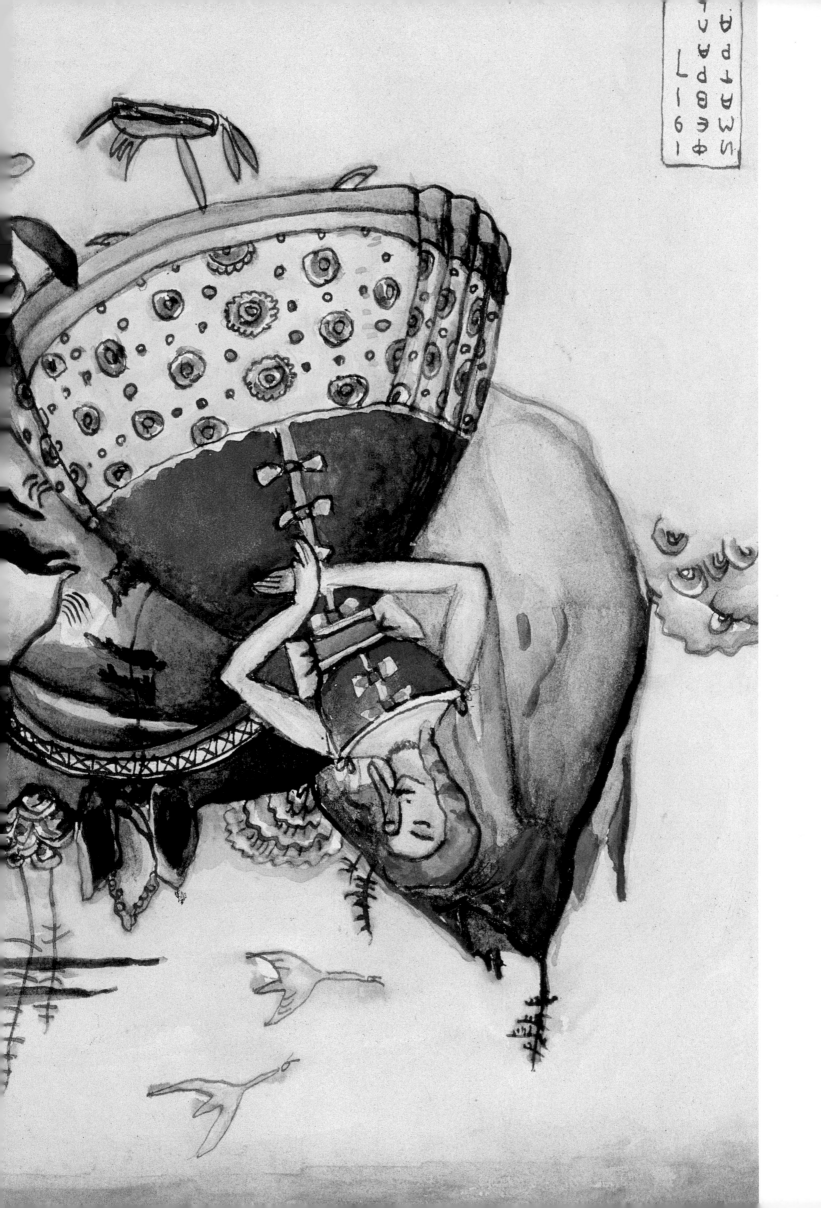

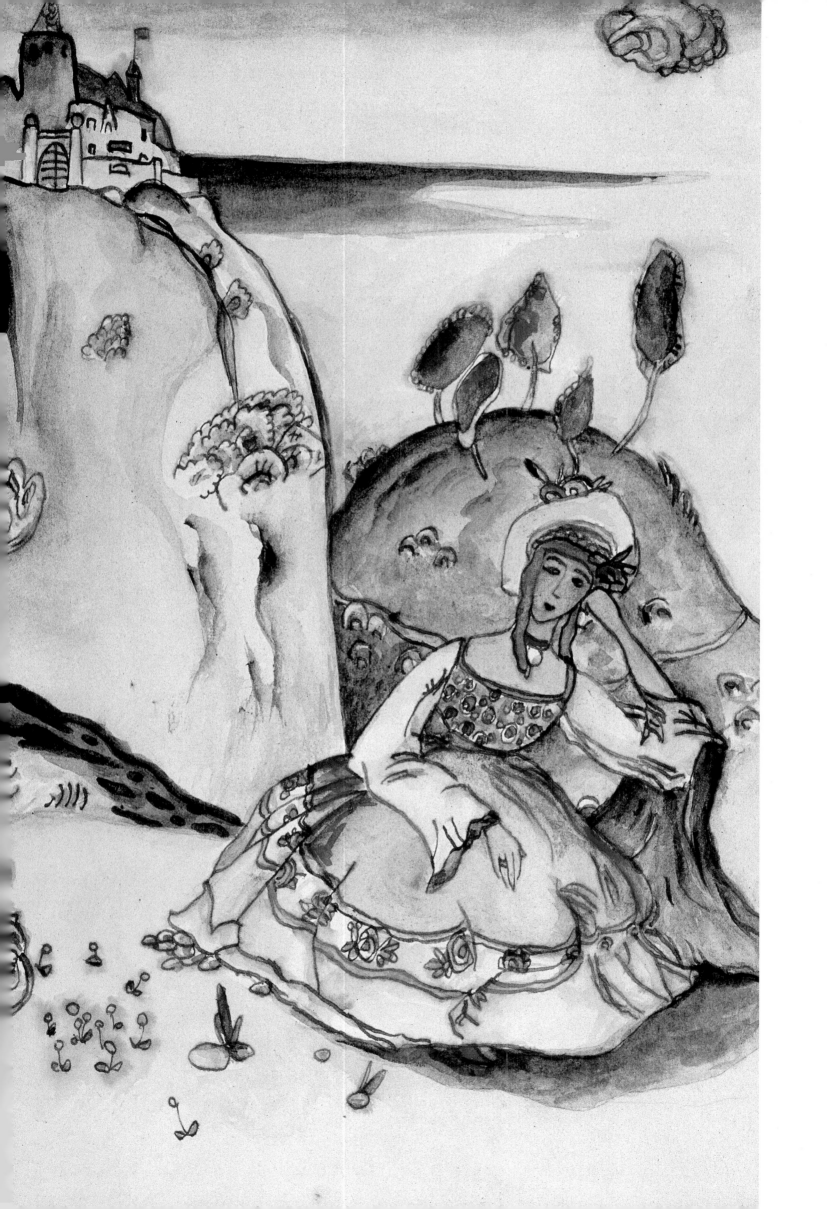

81 **Kasimir Malevitch**
*Military Popular Print*, 1914
Color lithograph, 33.7 x 56 cm
Russian Museum, St Petersburg

82 **Ilya Mashkov**
*Still Life With Pineapple*,
1908
Oil on canvas, 121 x 171 cm
Russian Museum, St Petersburg

84 (see pages 88–9)
**Mikhail Larionov**
*Venus and Mikhail*
Oil on canvas, 68 x 85.5 cm
Russian Museum, St Petersburg

Painted shop-signs eventually disappeared. They became unnecessary, too expensive in time and cost, thanks to the arrival of the machine-dominated world in which everything could be produced mechanically, and where there was no place left - in the severely insensitive urban environment - for *naïve* art that came from the heart. During the decades of the Soviet Union, some *naïve* artists continued to paint privately, deep within a closed family circle involving only family members and trusted neighbours who went on thinking of them as artists. Others joined the numerous art studios, so leaving the ranks of the *naïve* while yet not being accepted into the ranks of the professional artists.

The popular Russian Magazine *Ogonyok* has from time to time included prints of works of art by 'ordinary people'. In 1987 its readers were introduced to the pictures of Yelena Volkova. Brought up on an island not far from the Ukrainian city of Chuguyev, she tended to concentrate on painting riverside trees with bright green foliage, other scenes featuring people and animals, and equally colourful still-lifes. The disparate elements of everyday existence combine in Volkova's art to produce works that have much of the idyllic in them - a trait characteristic of many (and quite possibly all) *naïve* artists. A generally happy world is painted to portray that happiness, only in a brighter, richer, yet more serene way.

**83 Marc Chagall**
*The Market Place – Vitebsk*, 1917
Oil on canvas, 66,3 x 97 cm
Metropolitan Museum of Art, New York

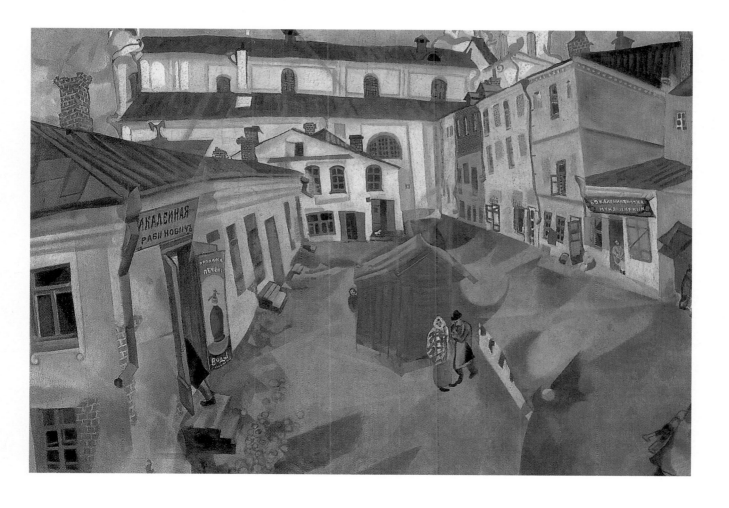

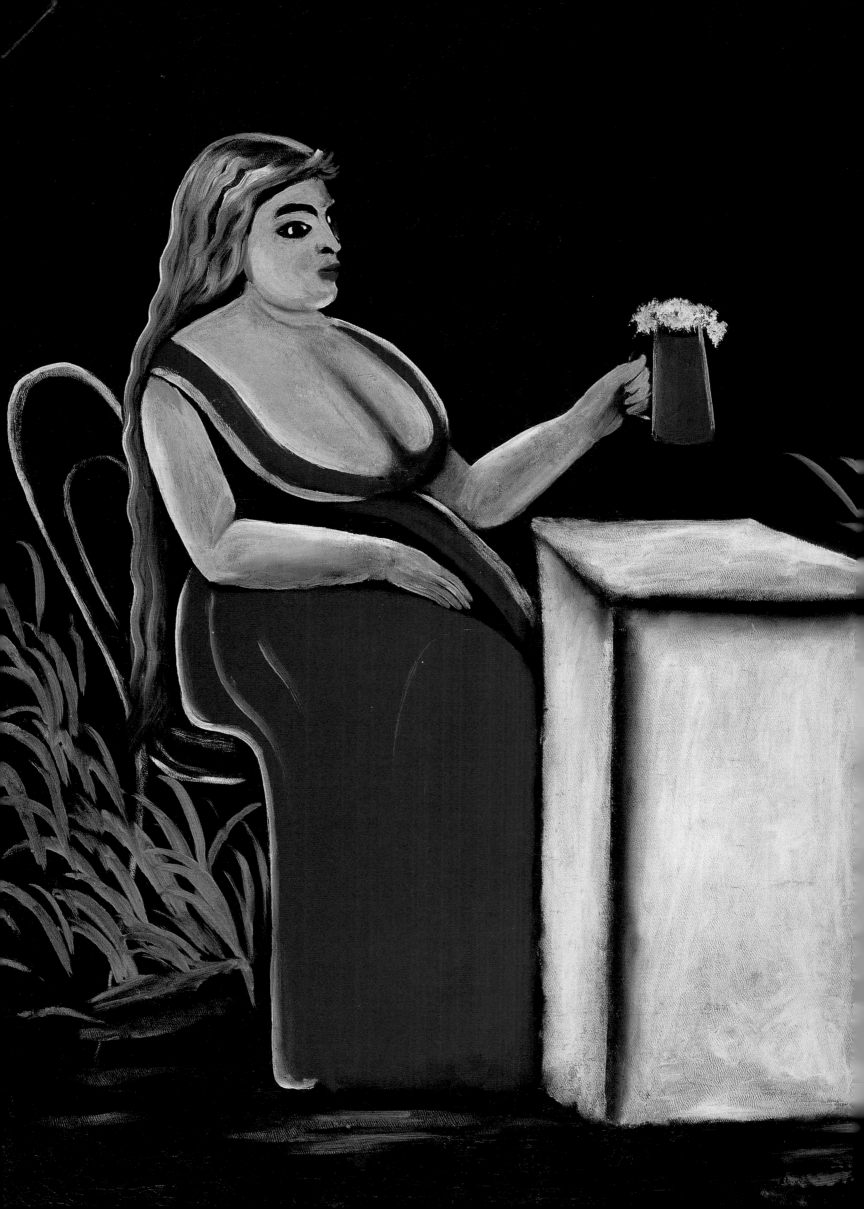

**85 Niko Pirosmani**
*The Girl With a Glass of Beer*
Oil on canvas, 114 x 90 cm
Georgian Museum of Fine Arts,
Tbilisi

Yelena Volkova came to painting at a mature age, but her creative imagination draws on her childhood memories, particularly those filled with the dazzling colours of the village fairs. Folk crafts were still blossoming in Russia in those days. Pottery, lacework, wooden toys and household articles, and so forth, were an integral part of ordinary rural life. Unhappily, today many of these traditions have been irretrievably lost. Yet aesthetic notions that derive from them continue to have some influence not only in rural districts but in urban areas too.

Eccentric personages who have a driving passion for painting pictures in their spare time should not automatically be associated with folk arts and crafts, however. On the contrary, such an association remains relatively rare by the end of the twentieth century. For one thing, whatever the conscious intentions of *naïve* artists are when they create their works of art, it is their own interests - their own choice of subject matter and presentation - that they are realizing. In that respect, such interests, influenced, for instance by the *kitsch* environment of a city market, remain the same no matter what or where the city is, no matter even if the city is Paris and the artists regularly visit the Louvre. But where this association between *naïve* art and folk art has been established in an

**86 Tutukila Carillo**
*Hewiixi folk pursuing Tacutsi,*
1973
122 x 89 cm

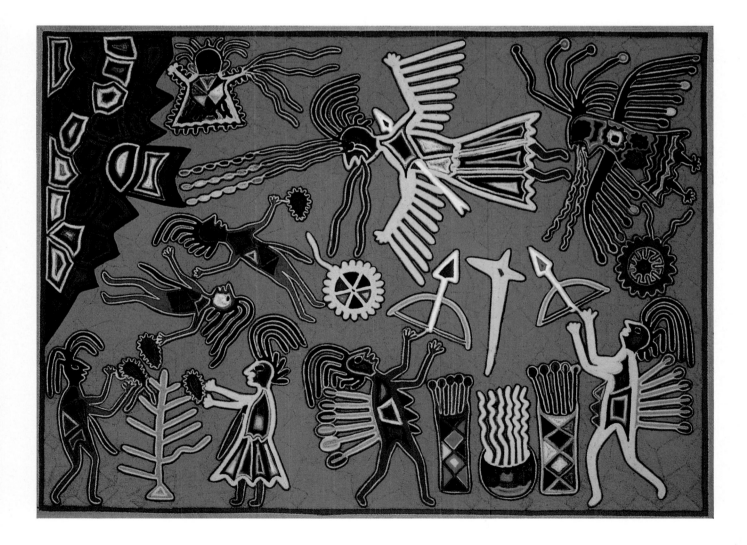

artist, is it possible to distinguish the different elements in the artist's work, to differentiate between the art of *naïve* art and the *kitsch* of the city-market folk art?

National characteristics manifest themselves in a much more powerful way in the sort of *naïve* art that is closely associated with folk art than in the unified classical system of art. Their presence is more evident where such an association remains intimate, most often in the work of rural artists, and less evident in the sanitized environment of a big city. Anatoly Yakovsky has suggested that a fondness for folk art is more noticeable in a country that has undergone a sudden transition from the era of the artisan to the age of the modern industrial complex.

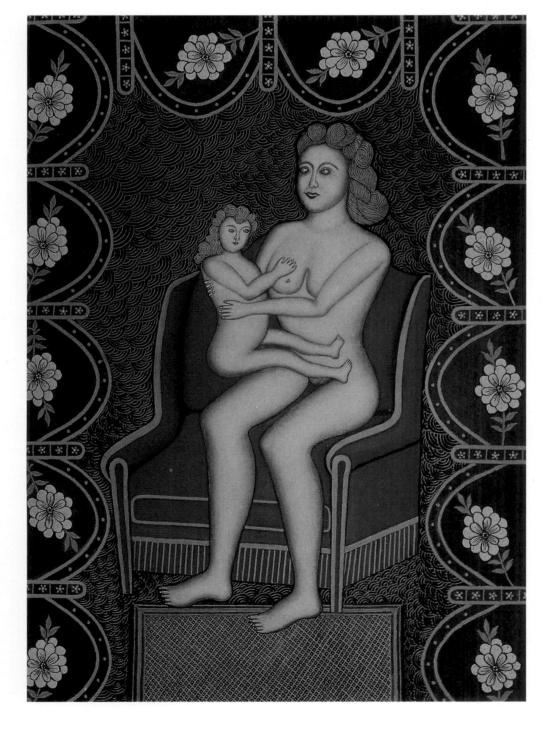

87 **Morris Hirshfield**
*Motherhood*
Charlotte Zander Collection, Munich

This would explain how it is that in some of the Latin American countries, for instance, or in Haiti, where there has been a synthesis of a darkly pagan religion with no less primitive forms of Christianity, enthusiasts have searched for and found *naïve* paintings of outstanding quality. The works of the Brazilian and Haitian *naïve* artists retain an essentially Brazilian or Haitian feel to them because their connection with the assorted influences of local religions and crafts has not yet loosened.

Back at that threshold between the nineteenth and the twentieth centuries, Russia was in the process of becoming an industrial power in Europe, yet its virtually medieval artistic craftsmanship remained pretty well unchanged. The diarist Walter Benjamin (quoted above) was astounded by the multicoloured diversity of life on the Moscow streets :

'Women - dealers and peasant-farmers - set up their baskets with their wares in front of them ... The baskets are full of apples, sweets, nuts, sugary confections... It is still possible here to find people whose

88 **Camille Bombois**
*The Gypsy Lady*, ca 1935
Oil on canvas, 73 x 60 cm
Museum Charlotte Zander,
Bönnigheim Castle

89 **Camille Bombois**
*At the Brothel*, ca 1930
Öl auf Leinwand, 46 x 55 cm
Museum Charlotte Zander,
Bönnigheim Castle

baskets contain wooden toys, small carts and spades. The carts are yellow and red, the spades are yellow or red... All the toys are simpler and more robust than in Germany - their rustic origins are very plain to see. On one street corner I encountered a woman who was selling Christmas-tree decorations. The glass spheres, yellow and red, were shining in the sun as if she was holding a magic basket of apples, some yellow and some red. In this place - as in some others I have been to - I could feel a direct connection between wood and colour.'[25]

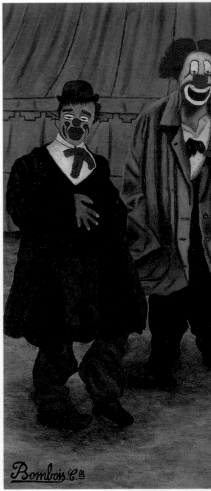

**90 Camille Bombois**
*Mario, Fratellino and Little Walter*
Öl auf Leinwand, 65 x 50 cm
Museum Charlotte Zander, Bönnigheim Castle

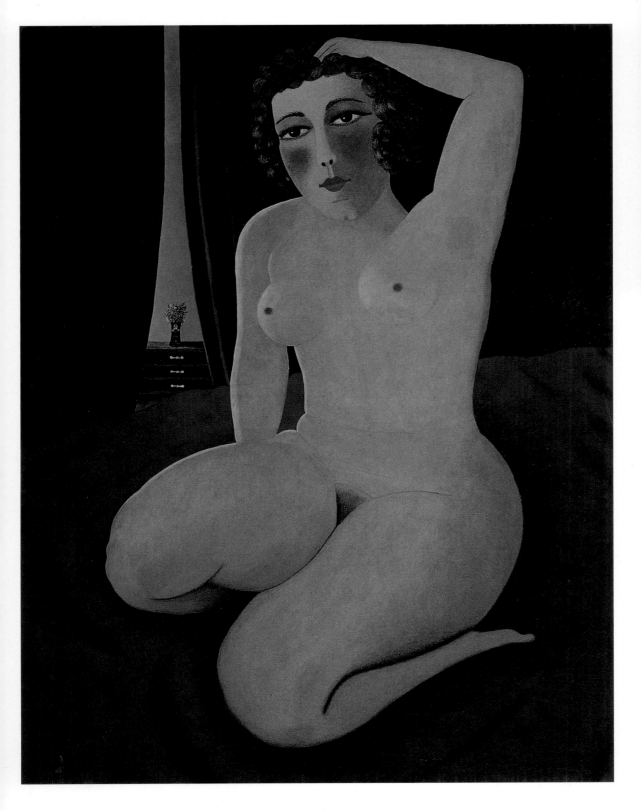

**91 Camille Bombois**
*Nude*

**92 Camille Bombois**
*The Athlete*, ca 1930
Museum of Modern Art, Centre Pompidou, Paris

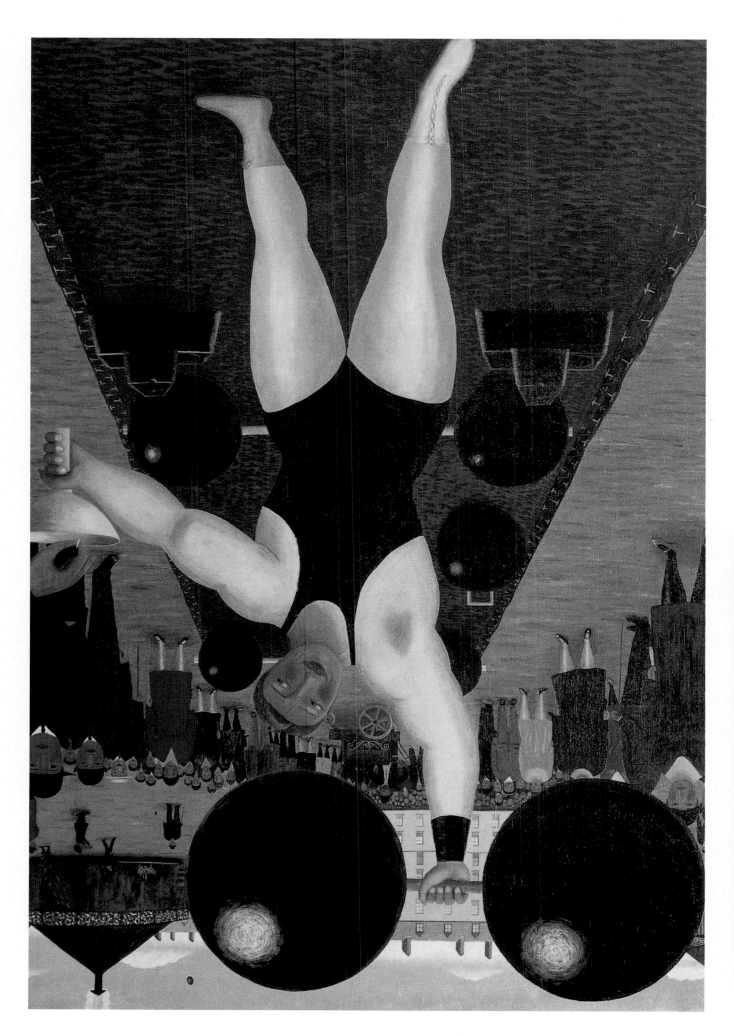
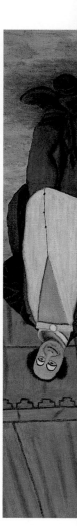

It was this multicoloured Russia which at the beginning of the twentieth century provided the impetus for a rejuvenation of painting, a new palette for the pictures of Boris Kustodiev, Wassily Kandinsky, Kasimir Malevich, Ilya Mashkov, Pyotr Konchalovsky, Aristarkh Lentulov and Marc Chagall, together with those of Mikhail Lrionov and Natalia Goncharova. And it was here, among its thronging city streets and markets, at the junction of East and West, where talented but untaught painters were devising and executing their own works of art. The artists 'discovered' by Larionov could hardly be compared with Niko Pirosmani - but the point is: they existed!

One of them has since become fairly well known. Morris Hirshfield was born in 1870 in what is now Poland but was then part of the Russian Empire. His pictures very much reflect the rural tastes of Polish life at the time, and feature clay cat-shaped money-boxes, wall-hangings with butterflies and flowers, and nudes.

The pictures of Camille Bombois also have a lot to do with fairs (at once stage he earned his living as a wrestler in a travelling circus), only for the most part those of Paris. His vigorous depictions of athletes, circus shows and nude models are the very embodiment of Parisian street life of the time.

For clear evidence of national traits in the work of *naïve* artists we need look no further than Krsto Hegedusic. His intention was specifically to identify the roots of Croatian art, and to encourage works that represented those roots. The result was not so much an artistic school that he founded at the village of Hlebin as a collection of individual talents all working according to similar precepts. Brightest among his protegés was Ivan Generalic.

93 Photograph of Krsto Hegedusic, 1962

## Ivan Generalic

Generalic was born in 1914, and for various reasons received only four years of formal education. He started painting on wood and glass - as was the custom in Balkan villages - and only later took to water-colour and oil painting on paper and canvas. In his approach to art he was a classic 'Sunday artist'. 'Generalic is a peasant - a real peasant - who does all the work in the fields and in the vineyard himself,' wrote Robert Wildhaber, who visited Generalic in search of folk art objects to display in his museum in Basel. 'When he has time, and in moments of inspiration, he sits and paints on the very table on which he served us our dinner... His bedroom he uses as a picture gallery. His own paintings hang there

94 Photograph of Ivan Generalic, 1962

interspersed with photographs. His custom is to paint on glass - only rarely does Generalic work on wood. It is quite delightful how this thickset giant of a man with the strong hands of a peasant is apt to explain that the wood of a tree is hard, and he does not always feel its inner warmth, but that he always feels the inner warmth in glass.'[26]

This last comment is especially interesting. Painting on glass has long been a traditional form of folk art not only in the Balkans but also in Switzerland, in France, in Germany and in the Ukraine, whereas painting

**95 Ivan Generalic**
*Nightscape,* 1964

96 **Ivan Generalic**
*In the Meadow*

on wood has been the standard form for village craftsmen and
icon-painters all over Europe and in much of the world besides. It is
natural, then, that wood and glass tend to be the media on which *naïve*
artists paint their first works, if not all their subsequent works. Most of the
talented rural painters of Hlebin have therefore continued to paint in oil on
glass for the duration of their creative life; rarely have they ever crossed
over to canvas. The connection with traditional, local arts and crafts by no
means disqualifies village artists of anywhere in the world from the
worldwide community of *naïve* artists. Such rural pictures have every right

to be regarded as a genuine easel-painting and to be compared with those of Rousseau. Rustic artists acquired their devotees and their patrons, and their works have become prominent in some museum collections.

In the comparatively small but diversely populated country of Switzerland, located right in the centre of Europe, there has long been concern that forms of folk art might disappear under the manifold pressures of industrial society. This is an area where the traditions of folk art exist perhaps less at the level of the nation than at the level of the canton: not only the artists themselves but the cantonal authorities too are much concerned to preserve what they can of their local culture.

Oil painting on glass (and in particular, the works of René Auberjonois, of Lausanne) has received some notable commendation from 'professional' artists, which constitutes formidable support for it. Artists of truly rustic traditions, however, have tended to paint in oil or water-colour on cardboard, and their primary subject matter has been the cows going up to an Alpine meadow. The oldest extant examples of paintings like this date back to the 1700s, although it is more than probable that such

**97 Ivan Generalic**
*River Landscape*, 1964

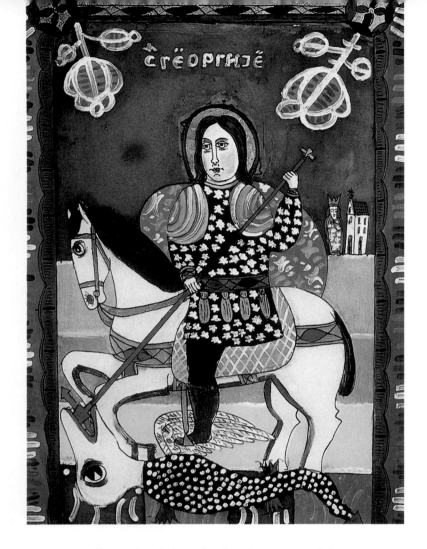

98 Anonymous painter
*St George Slaughtering the Dragon* (Glass painting)
Serbia, region of Vojvodina
Private collection, Italy

scenes really go back hundreds of years and focus on a geographical area surrounding the Säntis mountain group in the east of Switzerland, on the Liechtenstein border. Sharp outlines and an individual sense of colour in these works make them reminiscent of the Russian *lubok*. Unlike a *lubok*, however, each Swiss scene is signed by its artist, and the names of some Swiss artists of this sort have been known since the nineteenth century. Nor have they been forgotten in the meantime, thanks to their individual style and perception of the world.

One of them was Conrad Starck, perhaps most famous for the painted scene with which he decorated a milking-pail. Typifying the local Swiss scenery as he knew it, there is a cow, slung around the neck of which is a huge cow-bell; there is a rustic labourer wearing a red waistcoat above yellow trews; a rather sketchy tree; and some dogs, without which no Swiss mountain-farmer could work. This somewhat stereotyped though uninhibited approach by the artist is of course excused by the fact that it is all simply decoration for a milking-pail. Very much the same stock subjects are included also in another painting upon yet another milking-pail by Bartolomäus Lemmer in 1850, although the painting is totally different. The labourer is striding forward with a confident gait, a pipe between his teeth, followed by a shabby dog. A group of large, not to say fierce, cattle charge towards him in the

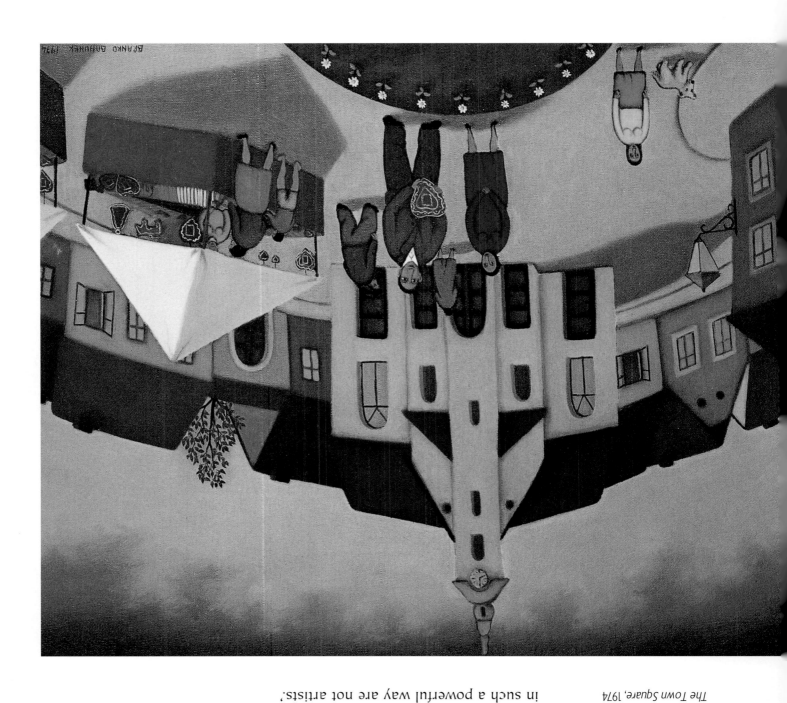

background. Such functional decoration is rarely painted with distinctive expressiveness or freedom. Many rural artists painted virtually nothing else but cows going up to an Alpine meadow, strangely clean farms, herds of goats and pigs, and the occasional yokel on a mountainside. But each artist had his or her own way of painting. For the most part the pictures were neither sensational nor innovative, especially when an artist was deliberately following an older, traditional style. Sometimes, just sometimes, the style is broad and free – a reminder that the artist has truly been part of the twentieth century. In this dual way the artists have created an image of their country that is comparatively modern and have yet preserved the spirit of the art of their tradition. To paraphrase the words of one of Henri Rousseau's defenders in the *Salon des Indépendants,* 'It is unreasonable to believe that people who are capable of affecting us in such a powerful way are not artists.'

## *Naïve* Artists and Photography

The end of the nineteenth century and the beginning of the twentieth gave *naïve* artists another source of inspiration. By this period photography had become so practicable that photographs - of parents, of brothers and sisters, of children and grandchildren, of entire family groups - decorated the walls of houses. This is the way it was in Ivan Generalic's house. For many people, from the time photography began to 'compete' with painting, the qualities of a photograph represented aesthetic criteria. The result was that some artists were simply defeated by it. Others, like Edgar Degas, turned the world-view as seen through the lends of the camera to their own advantage.

100 **Ivan Lackovic**
*Farmers Walking in the Snow*
Mona Lisa Gallery, Paris

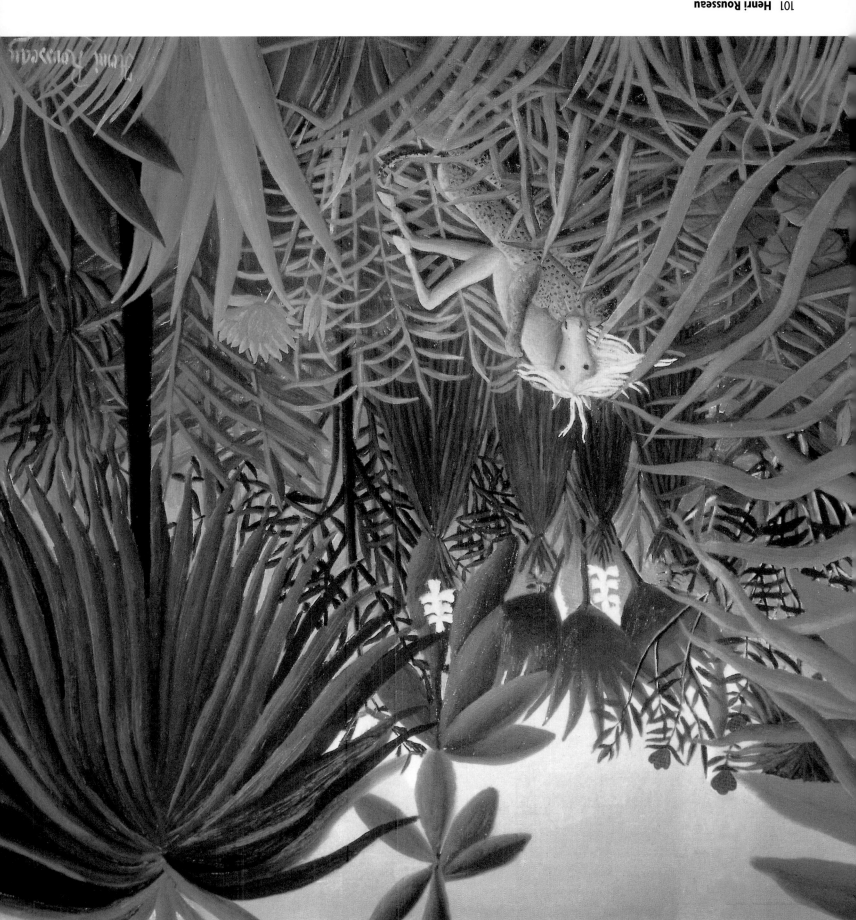

101 **Henri Rousseau**
*Victory of the Panther on the Horse*
Oil on canvas, 46 × 38 cm
Russian Museum, St Petersburg

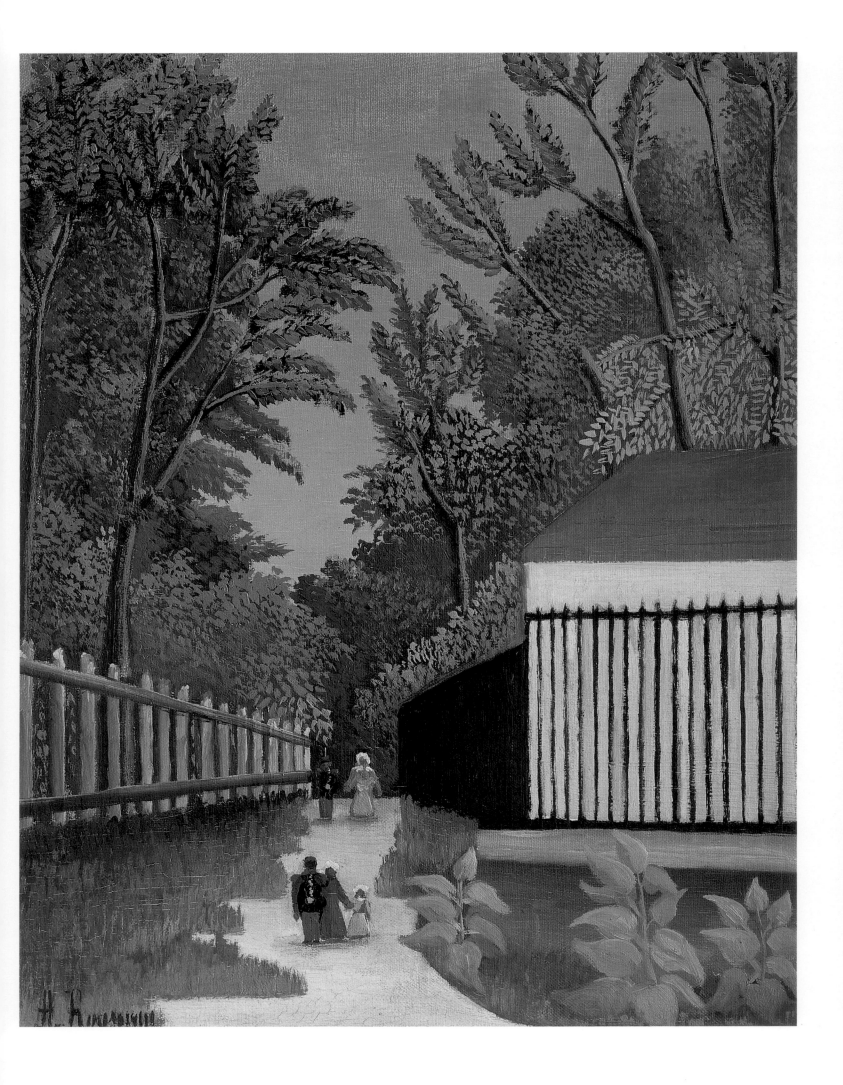

**102 Henri Rousseau**
*The Montsouri Park*, ca 1910
Oil on canvas, 46 x 38 cm
Russian Museum, St Petersburg

**103 Niko Pirosmani**
*A Janitor*
Oil on cloth, 102 x 135 cm
Georgian Museum of Fine Arts,
Tbilisi

Now it was possible to commission from the local artist a portrait of your child which should 'look like a photo', because photography had that unique ability to catch and retain an image with the honesty of a mirror. No idealization was allowed, and the scrupulous rendition of every little detail of a face or of clothing was not only mandatory but tended to influence the poses people took up and the overall composition of the picture.

**104 Orneore Metelli**
*Self-Portrait as a Musician*

It is often because they reflect the standards of photography that pictures produced by otherwise very different *naïve* artists - a French Rousseau, say, a Georgian Pirosmani, an Italian Metelli or a Polish Nikifor - may look similar. Rousseau's portrait of a female figure that was purchased by Picasso, and even the *Self-Portrait* by Joan Miró, conformed in many ways to the aesthetics of photography – not perhaps to those of genuine artists with the camera but to those of the photographers at fairs, who sat their models one after another on the same plain chair in front of the same velvet curtain.

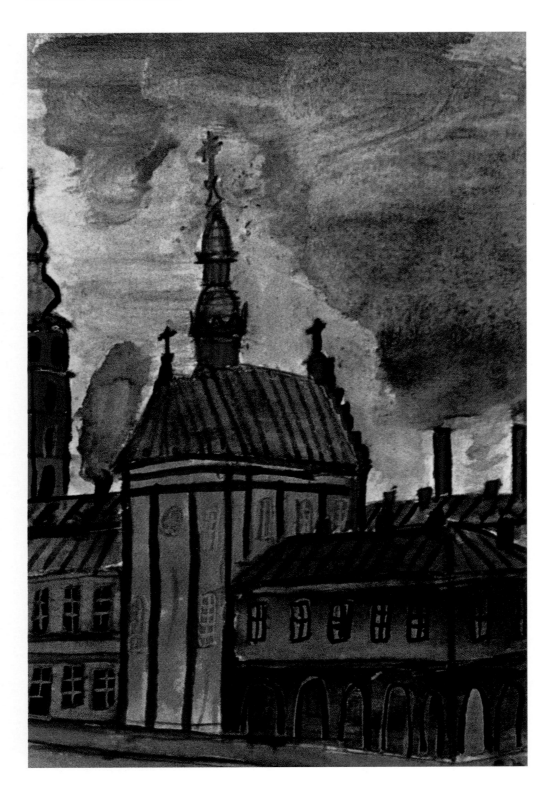

105 **Nikifor**
*The City*

Whereas reproductions and prints of paintings were not widely available, photography soon became an established part of urban and rural life. Photographers were to be found at bazaars and fairs among the stalls of folk arts such as painted pottery and crockery, woven baskets and rugs, and wooden artefacts. Photography entered every house as a form of art. Its influence on what people thought of 'art' is simply impossible to ignore. *Naïve* artists probably mastered the lessons of photography before the pros and cons of the medium in relation to professional art were fully appreciated by professional artists.

106 **Maria Palatini**
*The Christening of the Ship*

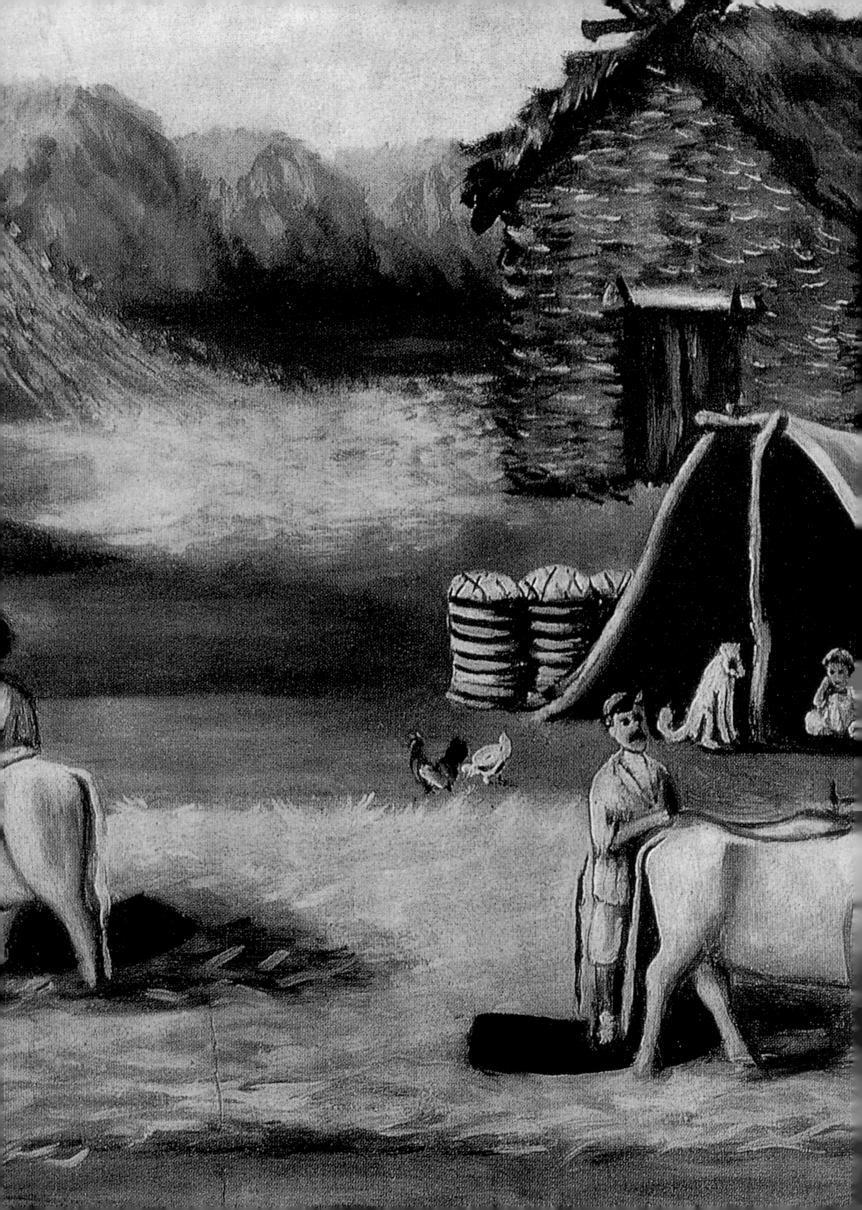

# Chain of Discoveries:
# from The West to The East

In 1904 the Russian artist Mikhail Larionov began to take an interest in the painted shop-signs that adorned the outsides of the shops of the city in which he lived. He incorporated some of them in a number of the urban landscapes he produced, and by doing so, 'invented' a new facet of art. He had discovered that pictorial representation even of such a casual kind as on shop-signs – generally ignored by everyone and certainly never seriously studied, 'invisible' details of everyday life – nonetheless added colour to an urban landscape and in many ways actually determined the face of that landscape.

At the end of the first decade of the twentieth century, another Russian artist, Boris Kustodiev, took the notion one stage further. Similarly finding inspiration in shop-signs, he not only incorporated them in his paintings but tried to learn from their uninhibited (and often garish) vividness and their utter directness of style. You could say that in deliberately searching out the unexpectedly interesting from within the familiarly ordinary, Kustodiev was the first person to make a study of what we now think of as *kitsch*. Before Kustodiev it would have been impossible to imagine that commonplace household carpets decorated by rustic hands with rustic patterns and rustic lack of skill, or clay cat-shaped money-boxes, could ever have been thought to have anything to do with folk art, let alone high art. Kustodiev's paintings of tradesmen's wives are full of such details. His stock characters and scenery are those of the Russian bazaar.

One form of rustic but very popular folk art, available in all Russian bazaars of the time and part of everyday life in the Russian countryside for centuries before, was the *lubok* or folk print. It now suddenly acquired a value and status equal to those of works by professional artists. In February 1913 the first-ever exhibition dedicated to the *lubok* opened at the Moscow School of Painting, Sculpture and Architecture, organized by Mikhail Larionov and Nikolai Vinogradov. Exhibits other than folk prints included decorated household trays, pieces

**ВЫСТАВКА
ИКОНОПИСНЫХЪ
ПОДЛИННИКОВЪ
И
ЛУБКОВЪ**

Организованная   **М.  Ф.  Ларіоновымъ**

**МОСКВА**
Большая   Дмитровка,   Художественный
Салонъ 11
**1913.**

**109** Cover for the catalogue of the exhibition of prototypical icons and lubok
prints, Moscow, 1913

of cooper-work, and carefully-moulded *pryaniki* - spiced biscuits. In his
Preface to the exhibition's catalogue Larionov wrote: 'All this is *lubok* in
the broadest sense of the term, and it is all high art.'[27]

　　Such an 'official' enthusiasm for standard objects of rural culture
produced for the most part by untaught amateurs who had never bothered
to sign their work created a veritable fever among the young people of
Russia. It caused the 'discovery' of several important *naïve* artists, of
which one was Niko Pirosmanashvili (Pirosmani).

**107  Mikhail Larionov**
*A Provincial Dandy*, 1907
Oil on canvas, 100 x 89 cm
Tretyakov Gallery, Moscow

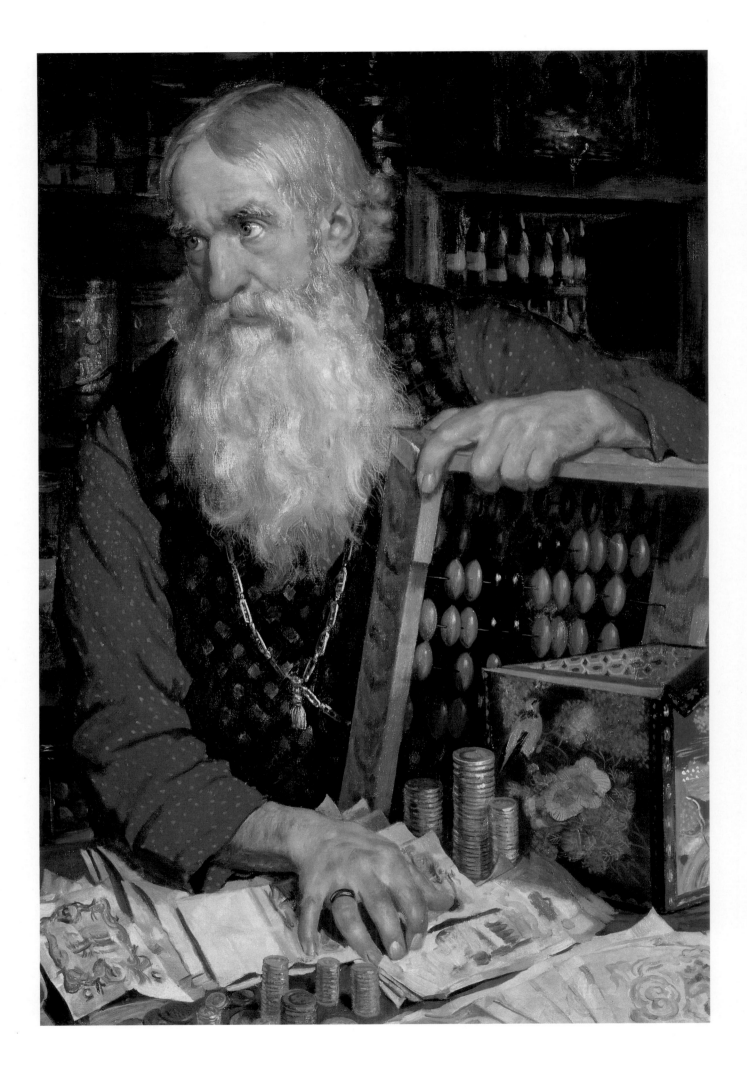

**113 Henri Rousseau**

*View on the Fortifications, From the Left
of the Vanves Gate*, 1909

Oil on canvas

Hermitage, St Petersburg

could do nothing but stand there in silence to marvel... The artist was self-taught, but his technique and his understanding of the medium he was using testified to his skill and the originality of what he was doing. Looking at the pictures more closely, we realized that they were painted on black oilcloth, and that the black in the pictures was where the oilcloth had been left unpainted...[29] We raised our glasses to the artist and his pictures, and asked who this genius was, where he lived, and what his name was. Everybody in the room reacted with animated astonishment that we had never heard of Niko the house-decorator.'[30] The newspapers of the Georgian capital were shortly afterwards to publish the first appreciative articles on the paintings of Niko Pirosmanashvili.

114 **Séraphine Louis**
*Bouquet*, ca 1927-8
Oil on canvas, 117 x 89 cm
Museum Charlotte Zander,
Bönnigheim Castle

115 **Séraphine Louis**
*Bunch of Flowers*
Oil on canvas, 120 x 89.5 cm
Museum Charlotte Zander,
Bönnigheim Castle

'It turned out', Zdanevich carried on, 'that many in Tbilisi knew about Pirosmani's paintings but dismissed the idea that they might be true art because they were painted on oilcloth. They looked nothing like pictures you might see at an art exhibition, and above all, they were hanging only in some of the lowest dives in the city.'[31] It was true. The

116 **Louis Vivin**
*Allegory*
Oil on canvas, 91.5 x 76 cm
Museum Charlotte Zander,
Bönnigheim Castle

**117 Louis Vivin**
*St-Martin Gate*
Oil on canvas, 50 x 61 cm
Museum Charlotte Zander,
Bönnigheim Castle

only people who were really familiar with Niko's work were the customers of some of the cheapest restaurants in the outlying districts of Tbilisi. Hardly any of Tbilisi's cultural nobility - the intelligentsia of the city - had ever heard of him, let alone knew of his work. It was only after his death - which occurred in 1918 - that Pirosmani became renowned among his friends and acquaintances as something of a 'martyr of art'.

The same was not true, however, in Russia. In March 1913 no fewer than four of Pirosmani's works were put on display in an exhibition in Moscow entitled *Mishen* ('Target'). Several of his signs' were also put on display there for the first time.

To be the 'discoverer' of a *naïve* artist suddenly became extremely important for Russian avant-garde artists. Larionov determined to find a 'Russian Pirosmani', and eventually unearthed a certain mineworker T. Pavlyuchenko and a Sergeant Bogomazov whose works he

118 **Louis Vivin**
*Still Life with Butterflies
and Flowers*
Oil on canvas, 61 x 50 cm
Museum Charlotte Zander,
Bönnigheim Castle

displayed at the *Mishen* exhibition. Their productions have since been lost, but the fact that they appeared alongside the works of professional artists meant that *naïve* artists could turn up just about anywhere. It has to be said, though, that there was one grave disadvantage against *naïve* pictures of this kind when they were put on display: they were not considered true art.

In this way, the 'Rousseau banquet' may well be thought of as the symbolic beginning of the nascent group of *naïve* artists. And from that beginning the doctrine was spreading.

In Croatia during the 1920s the artist Kristo Hegedusic formed a group known as *Zemlya* ('Earth') with the specific purpose of finding the roots of national art. In a village called Hlebin he discovered some extraordinary paintings by a sixteen-year-old peasant boy named Ivan

Generalic. The lad later himself became the leader of a group of local artists.

In Switzerland, a museum in the town of Sankt Gallen (Saint-Gall) started collecting pictures painted by the rural folk who lived in the mountains around. Many such paintings were then displayed in a large exhibition of Swiss folk art in Basel in 1941.

119 **Camille Bombois**
*At the Bar*
Oil on canvas, 55 x 46 cm
Museum Charlotte Zander,
Bönnigheim Castle

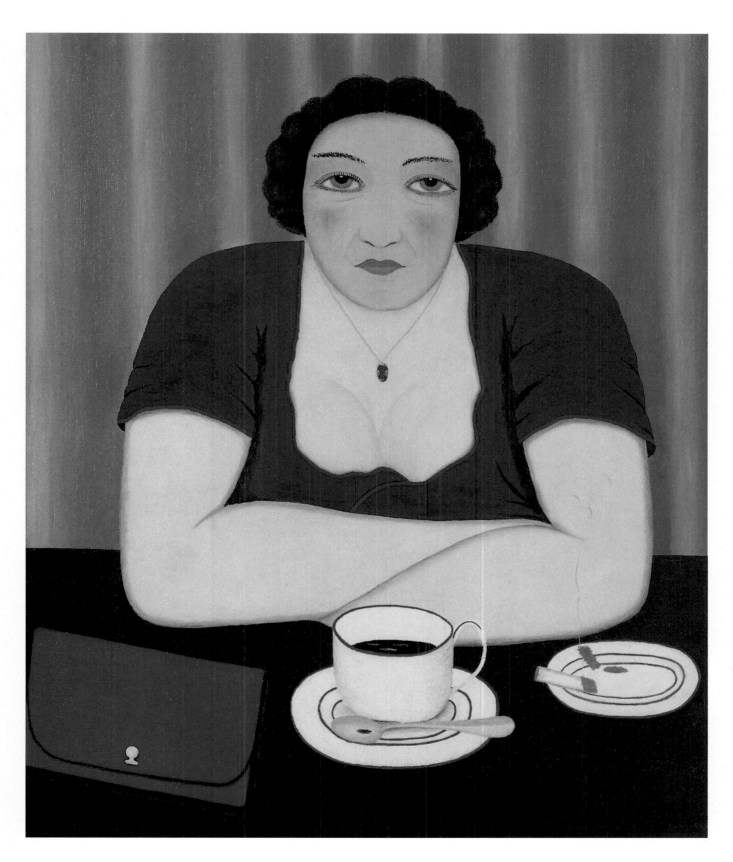

But for the most part, talented self-taught artists tended to crop
up in cities where, quite naturally, it was easier for them to come into
contact with professionals. Back in France, that very same Wilhelm Uhde
who had enraged Gustave Coquiot by 'discovering' Henri Rousseau
mounted an exhibition of the works of *naïve* artists in the Galerie des
Quatre Chemins in Paris in 1928. It featured several paintings by
Rousseau, but there were also works there by Séraphine Louis, Uhde's

**123 Camille Bombois**

*A Naked Woman Sitting*, ca 1936

Oil on canvas, 100 x 81 cm

Museum Charlotte Zander, Bönnigheim Castle

housemaid, by Louis Vivin (who had been 'discovered' by professional artists in Montmartre), by Camille Bombois (who had been 'discovered' by a Parisian journalist) and by André Bauchant (who had been picked out by the architect and designer Le Corbusier at the *Salon d'Automne* in 1921).

But *naïve art* was not the sole preserve of Europe. The United States and the countries of Latin America, countries of the Middle East and the Orient all found their own Henri Rousseaus living in their midsts, and duly presented them to the world.

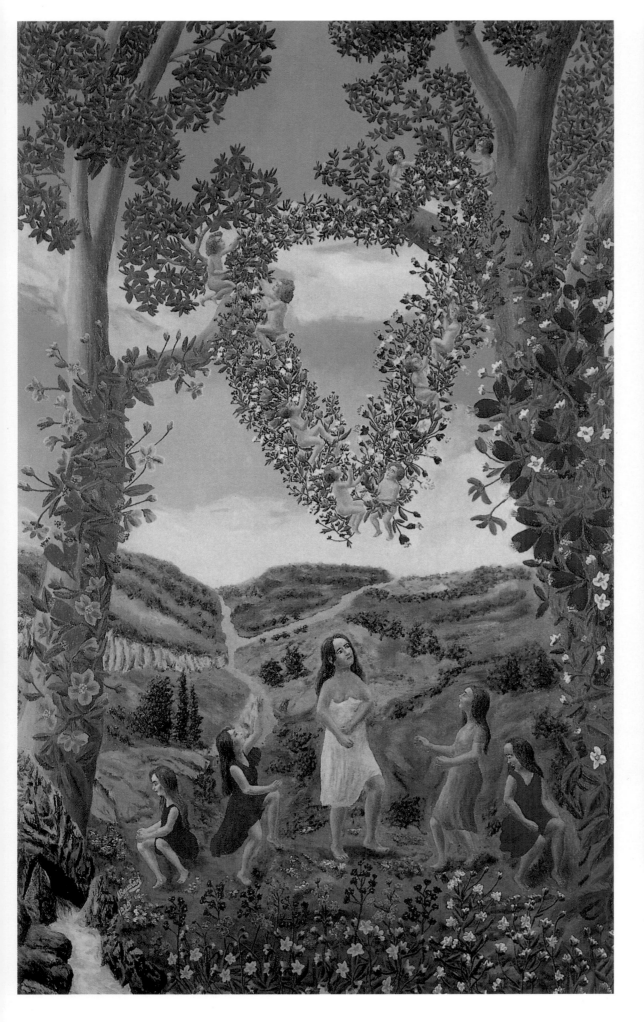

124 **André Bauchant**
*Love and Flowers*, 1929
Oil on canvas, 174 x 109 cm
Museum Charlotte Zander,
Bönnigheim Castle

**125 André Bauchant**
*Motherhood*, 1943
Oil on canvas, 54 x 44 cm
Museum Charlotte Zander,
Bönnigheim Castle

**126 André Bauchant**
*Still Life With Rabbit*, 1924
Oil on canvas, 100 x 67 cm
Museum Charlotte Zander,
Bönnigheim Castle

## The *Naïve* Artist as a Personality: Pirosmani

When the Zdanevich brothers saw the paintings of Niko Pirosmanashvili,
they reminded them immediately of the work of Henri Rousseau –
although they were very different indeed. Whereas Rousseau's work was a
product of the cosmopolitan city of Paris, Pirosmani's could only be
Georgian and from nowhere else. He lived in Tbilisi, a fascinating city, the
capital of Georgia and cultural centre of the entire TransCaucasian region.
In Tbilisi the feudal Georgian way of life tended to complement the
otherwise foreign European stratum of culture.

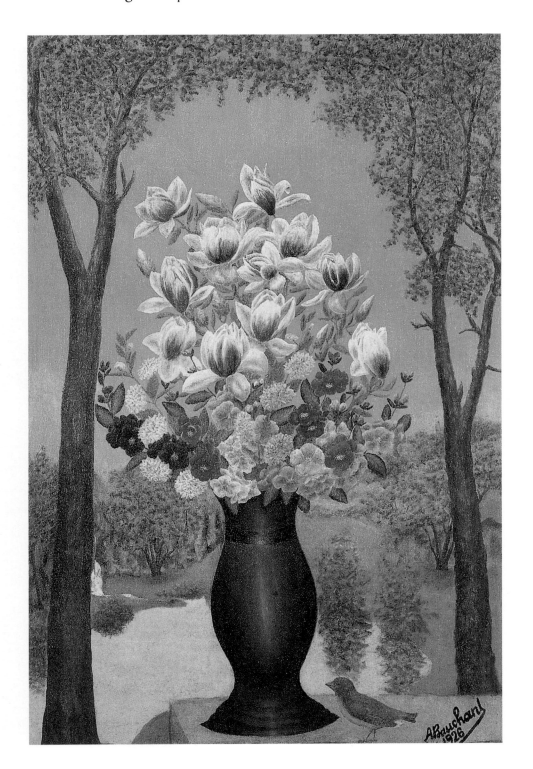

127 **André Bauchant**
*Bunch of Flowers in a
Landscape*, 1926
Oil on canvas, 100 x 67 cm
Museum Charlotte Zander,
Bönnigheim Castle

128 **André Bauchant**
*Mother and Child with a
Bunch of Flowers*, 1922
Oil on canvas, 72.3 x 58.5 cm
Museum Charlotte Zander,
Bönnigheim Castle

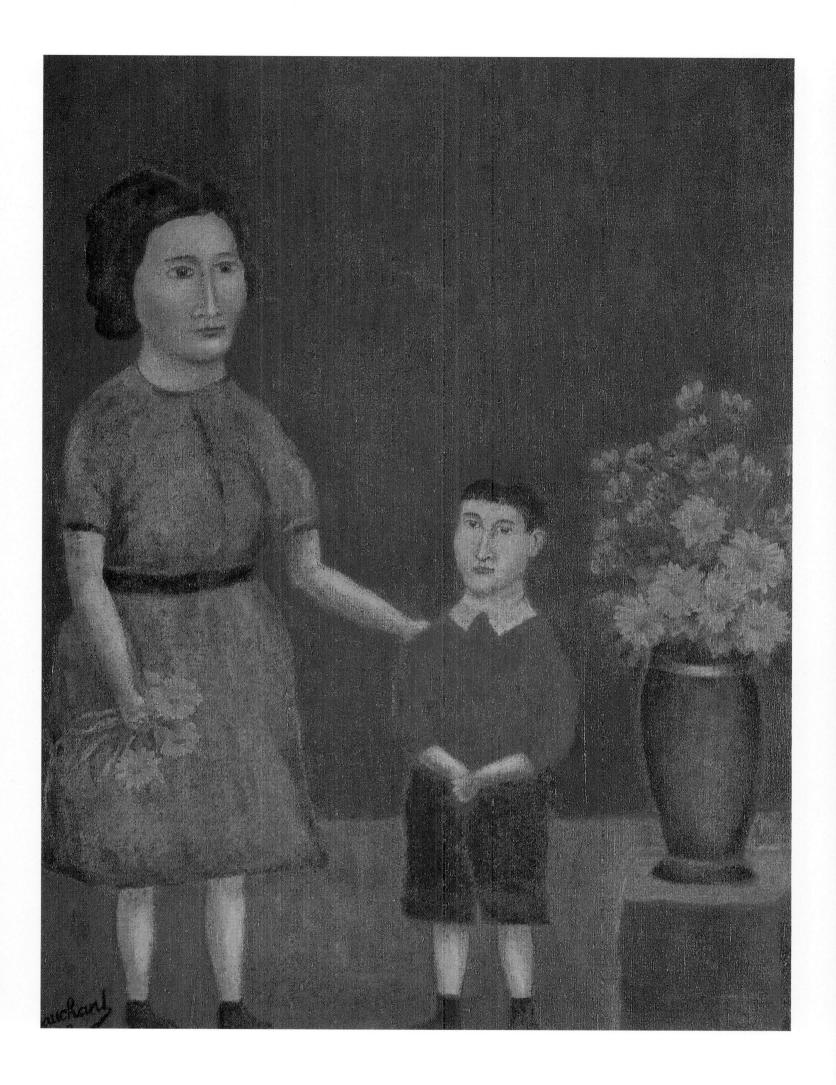

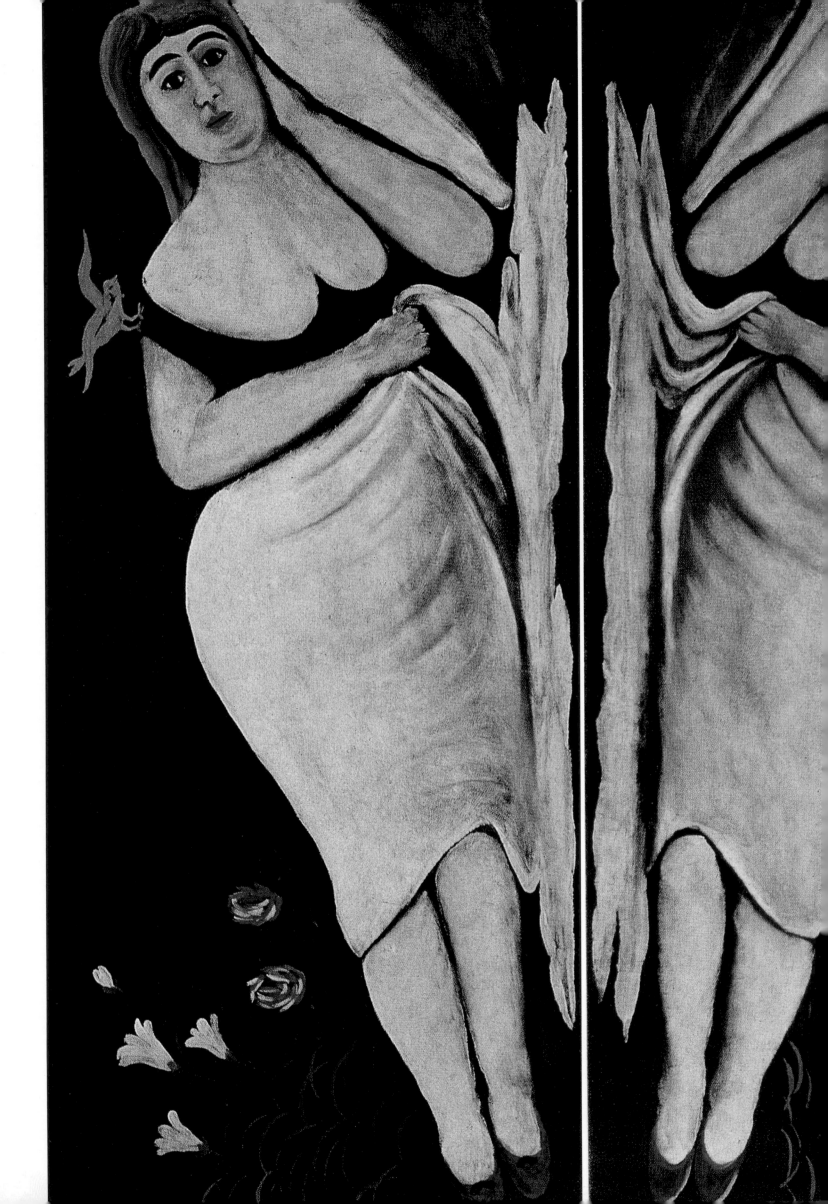

**129 Niko Pirosmani**
*The Beauty of Ortatchal, First half of a Diptych*
Oil on canvas, 52 x 117 cm
Georgian Museum of Fine Arts, Tbilisi

**130 Niko Pirosmani**
*The Beauty of Ortatchal, Second half of a Diptych*
Oil on canvas, 52 x 117 cm
Georgian Museum of Fine Arts, Tbilisi

**131 Niko Pirosmani**
*A Barn*
Oil on cardboard, 72 x 100 cm
Georgian Museum of Fine Arts, Tbilisi

**132 Niko Pirosmani**
*The Grape-Pickers*
Oil on canvas, 118 x 184 cm
Georgian Museum of Fine Arts, Tbilisi

Niko belonged to the lowest stratum of society in Tbilisi. 'Niko - the "house-painter" - is one of the poorest of all the down-and-outs who find shelter in the outskirts of Tbilisi,' wrote Kyrill Zdanevich. 'He has not had his own place to live in for a long time now, and stays in the house of one patron after another, sometimes working in the filthiest slums... and sometimes in the larger rooms of *dukhans* [restaurants]. In these surroundings he generally gets at least a bowl of soup, and if the patron is pleased with the picture he may even be served a glass of wine. Having come to the end of one commission, Niko takes up his paint-box and his home-made brushes and moves on to the next...'[32] He did not want to go back to where he had come from, the Alazan valley, because he did not

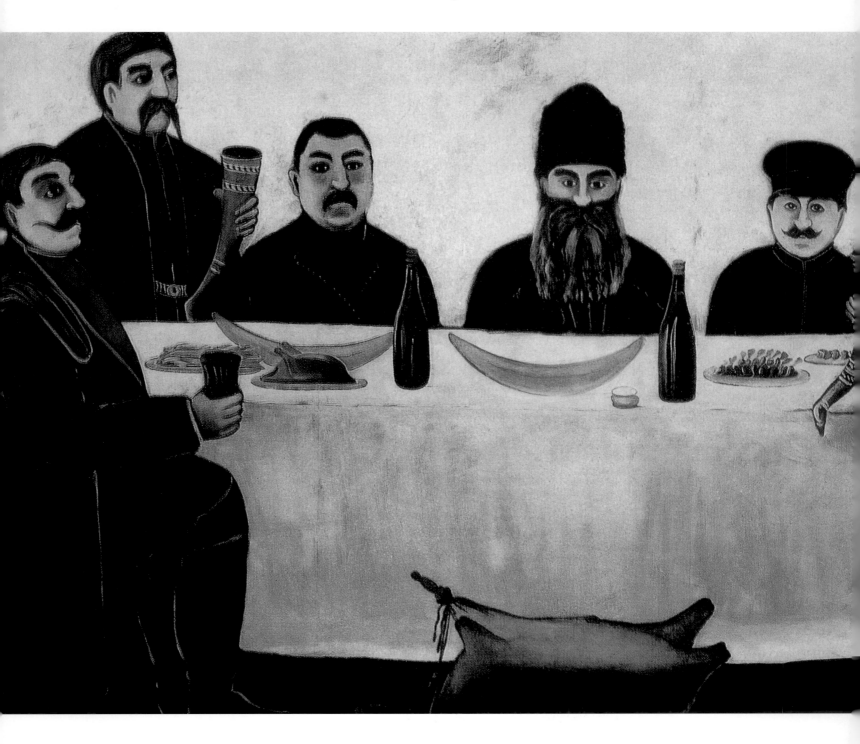

133 **Niko Pirosmani**
*The Bego Company*
Oil on canvas, 66 x 102 cm
Georgian Museum of Fine Arts, Tbilisi

want his sister or his former neighbours to see what poverty he had been
reduced to. Yet even when he had achieved some recognition in Tbilisi,
and some comparatively well-known artists considered him to be one of
them, inviting him therefore to attend a meeting of the Artist's Union, he
would not change his lifestyle.

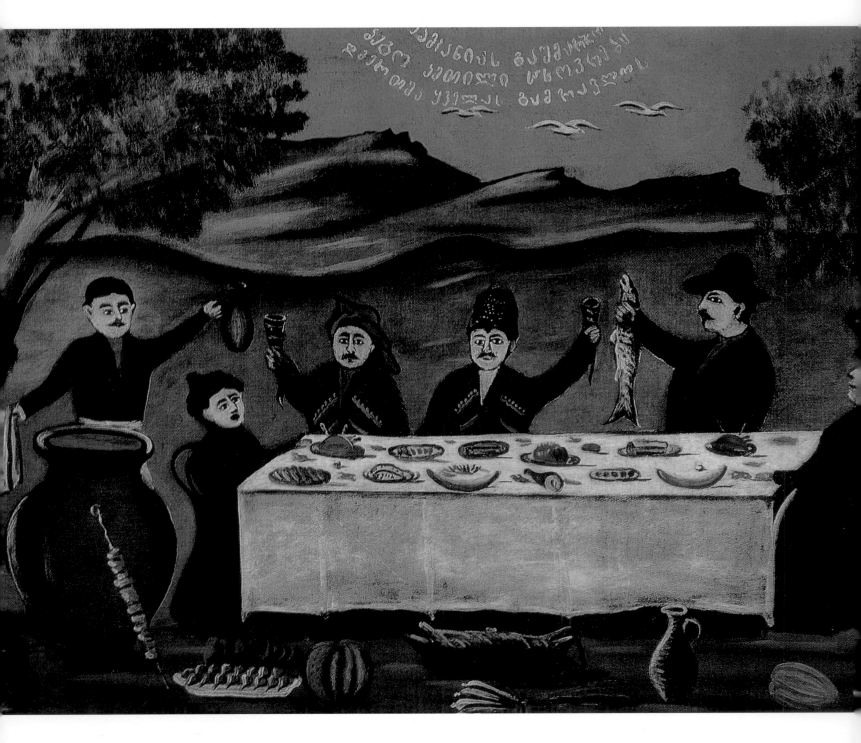

Niko made an indelible impression on everyone who met him. The poet Ilya Zdanevich described how he and his brother first saw Niko at the side of a road in the old part of Tbilisi:

'He was painting the word DAIRY on a wall, using a brush, as a wall-sign. On our approach he turned round, bowed with great dignity, and turned back again to his work. Thereafter he supported our conversation with an occasional remark. I remember that meeting well. It was an artist who was standing at that white wall in a torn black jacket and a soft felt hat. He was tall, calm and self-confident, though not without a certain trace of sadness in his manner. (His acquaintances gave him the friendly nickname of 'the Count').'[33]

135 **Niko Pirosmani**
*The Wedding*
Oil on canvas, 113 x 177 cm
National Museum of Oriental Art, Moscow

136 **Niko Pirosmani**
*A Bear in the Moonlight*
Oil on cardboard, 100 x 80 cm
Georgian Museum of Fine Arts, Tbilisi

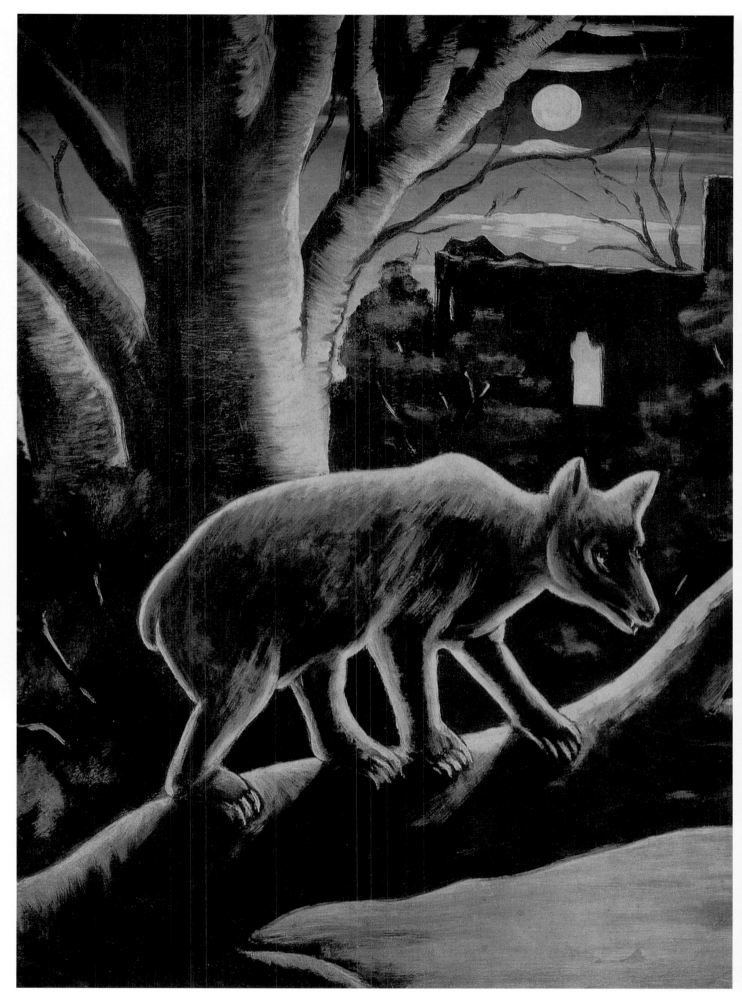

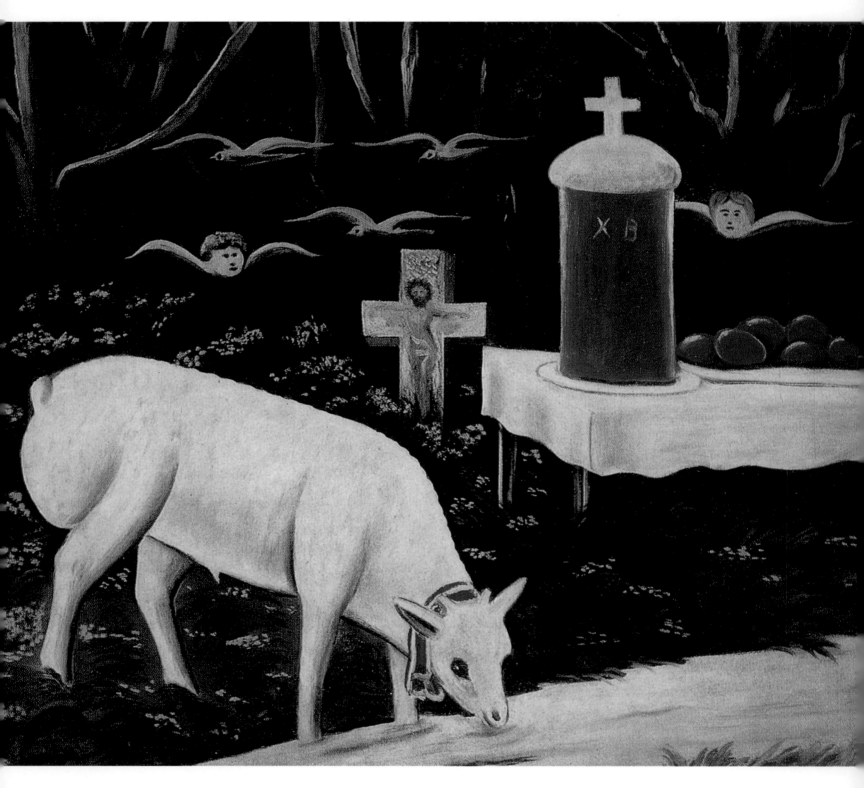

No one had ever taught him to paint. He started on wall-signs painted directly on to the walls or on squares or rectangles of tin. Had Niko never actually come to Tbilisi it is possible that he might instead have become an icon-painter in his native Keheti, where the walls of the medieval churches were covered with the most marvellous and well-preserved frescoes. The influence of such frescoes is visible in Niko's work, particularly in the broad and stylistically general manner of painting (with the flat background and large figures) that makes his pictures instantly recognizable.

137  **Niko Pirosmani**
*A Lamb and a Laden Easter Table With Angels in the Background*
Oil on oilcloth, 80 x 100 cm
Georgian Museum of Fine Arts, Tbilisi

**138 Niko Pirosmani**

*Woman With Flowers and an Umbrella*

Oil on canvas, 113 x 53 cm

Georgian Museum of Fine Arts, Tbilisi

139 **Niko Pirosmani**
*A Fisher*
Oil on canvas, 111 x 90 cm
Georgian Museum of Fine Arts,
Tbilisi

His first job, however, was on the railway network. He then
turned minor tradesman, went bankrupt, and began to earn a living by
doing what he had always loved to do since childhood. His imagination
transformed restaurant-signs into glorious compositions that portrayed
feasts and banquets, picnics with *shashliyk* (kebabs), and still-lifes with
sausages and fruit and clay jugs. A typical 'Sunday artist', he painted for
himself, although what he produced had to be used as payment for food
and drink, which was after all what Henri Rousseau was sometimes
similarly obliged to do. Yet his pictures were genuinely Georgian in style.
They embodied the life and times of his country. The people he portrayed
could be anything from janitors to bandits, restaurateurs to princes,
aristocrats to beggars (with or without children), and fops to bourgeois
party-goers. At the foundation of his imagination were the vineyards of his
home in Keheti, the rural labourers and shepherds of the region, the

140 **Niko Pirosmani**
*The Actress Marguerite*
Oil on canvas, 117 x 94 cm
Georgian Museum of Fine Arts,
Tbilisi

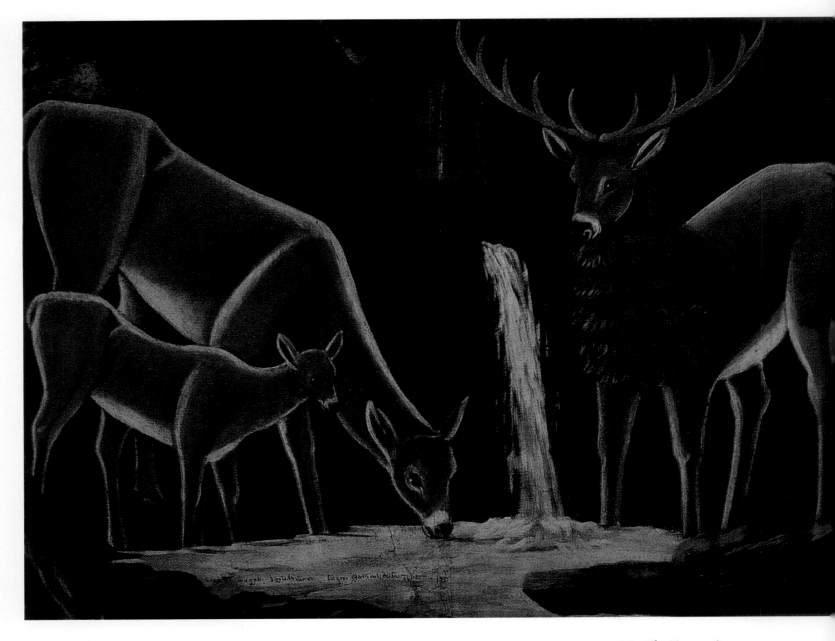

square architecture of the medieval churches there, and a strong liking for the shape of (oversized) ancient amphorae. Niko's paintings present us with a clear and virtually complete picture of the 'mythology' of contemporary Georgia. In addition, his pictures are full of wildlife: pigs and rams, donkeys and camels, lions and eagles, and, of course, deer. Graceful and delicate, deer symbolize Georgian pride and independence, even as their eyes reveal human sadness. The makers of local Georgian pottery often made deer figurines.

His use of black oilcloth was determined by the general rule that signs should be painted within a black border. This colour, however, plays a highly specific role in Georgian culture. It is the standard colour of the clothing of both city and rural dwellers. Nothing in the world resembles the black pottery of Georgian ceramics. So black oilcloth was a godsend to a painter so subtle as Niko Pirosmani - it helped to create unearthly decorative effects, to enhance the romantic mood in moonlit night scenes,

141 **Niko Pirosmani**
*A Deer Family*, 1917
Oil on cardboard, 95 x 145 cm
Collection of the Grammeleki
family, Tbilisi

142 **Niko Pirosmani**
*A Deer*
Oil on canvas, 138 x 112 cm
Georgian Museum of Fine Arts,
Tbilisi

143 **Niko Pirosmani**
*Son of a Kinto*
Oil on oilcloth, 77 x 38 cm
Georgian Museum of Fine Arts,
Tbilisi

**144 Diego Velásquez**
*Portrait of the Infante Don
Carlos,* ca 1626
Oil on canvas, 209 x 126 cm
Museum of the Prado, Madrid

and finally to produce those large forms of which the only analogues are
to be found in Spanish painting of the seventeenth century.

And it is on this point that we touch upon the second most
important question: the relationship between *naïve* artists and professional
'academic' artists.

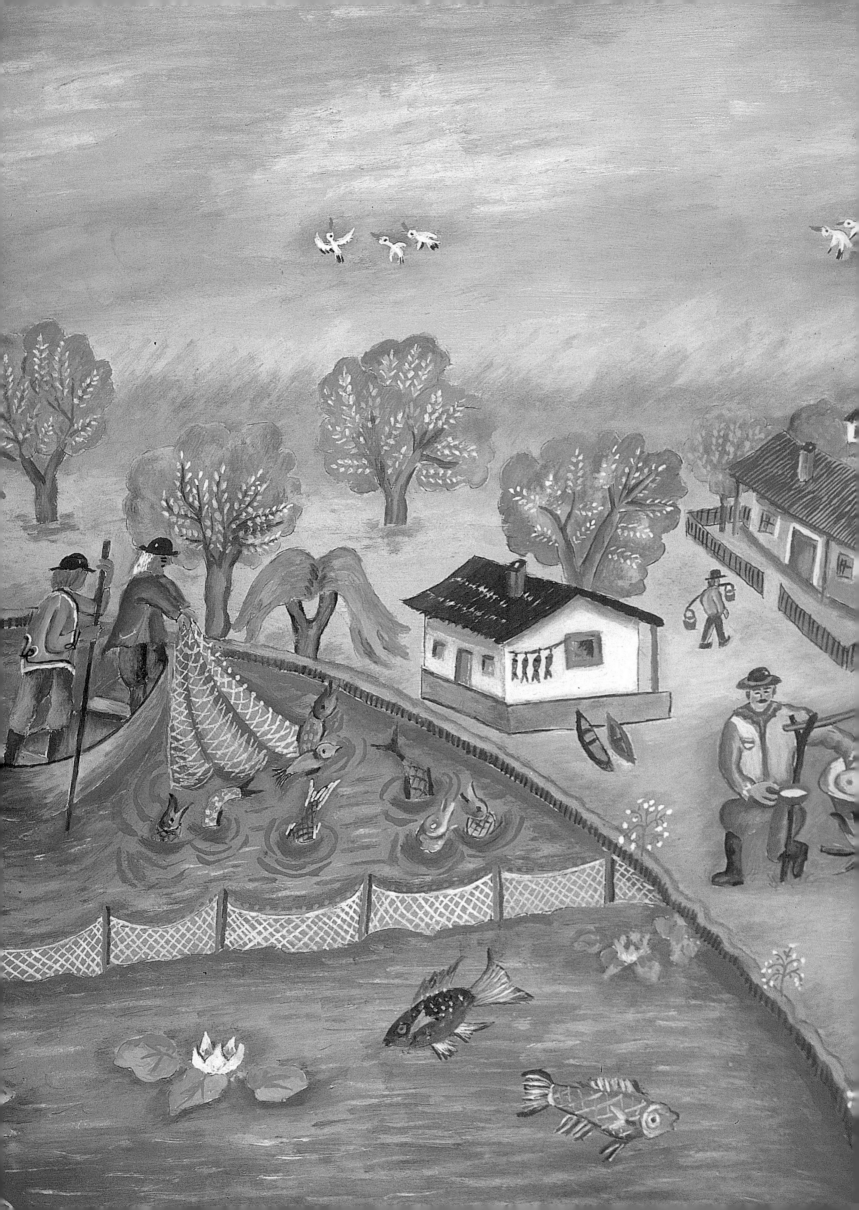

A. Lupaşc

# Naïve Painting in Romania

Popular art in Romania, and particularly rural art, has been largely of one and the same style across the centuries, although differing in regional aspects.

Documents that have come down to us from the nineteenth century and the period immediately before then – from the seventeenth and, especially, from the eighteenth centuries – demonstrate more or less directly (in prints and in water-colours) the wide-ranging artistic enthusiasm of the middle classes in contemporary provincial Romania.

145 **Ion Arca**
(Dâncu Mare, Hunedoara area)
*Folk Dance ('Calusarii')*
Oil on canvas, 50 x 60 cm

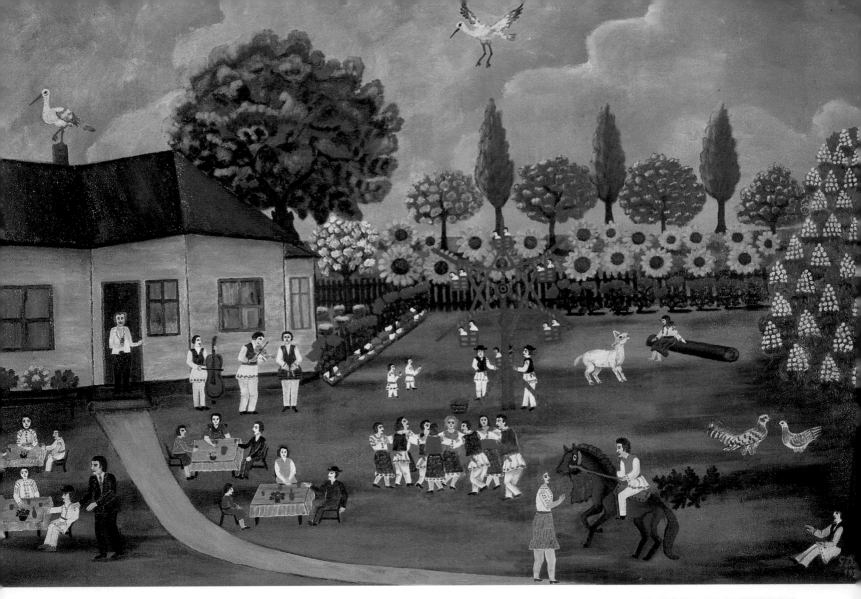

146 **Gheorghe Dumitrescu**
(Titu, Dambovitza area)
*Festival Day*
Oil on card, 35 x 48 cm

147 **Paula Iacob**
(Vaslui, Moldavia)
*The Clowns*
Oil on canvas, 50 x 40 cm

**148 Ana Kiss**
(Târgu Mureș, Mureș area)
*Making One's Farewells*
Oil on card, 42 x 53 cm

Additional evidence for this is provided by the carefully carved wooden ornamentation on architectural features, the elaborate painting of household furniture, the hand-embroidered tapestry wall-hangings, and the highly decorative ceramics. All these practical applications of the arts together exhibit a distinctive character that was no less profound for being the product of non-professional craftspeople, and constitute works of the precursors of what today are known as the *naïve artists*.

At a European level, the representation of popular artistic sensibilities by people who had not been professionally taught and who, indeed, were outside of the mainstream of the applied arts – the so-called *naïve* artists, sometimes held to produce 'secular iconography' in painting or sculpture – received proper recognition only after a considerable time had elapsed. In Romania it was to have its echoes during the 1960s.

It was the work of the *naïve* painters of what used to be
Yugoslavia that caught the interest of Romanian art critics, who then took
upon themselves the difficult task of discovering '*naïve* art' in Romania.
And to their own huge amazement, by scouring the dusty nooks and
crannies of houses and entire villages, by dusting over just about
anywhere that such artistic works of amateurs might have been stored
out of sight, they actually did come across incontrovertible evidence
of Romanian *naïve* art dating from a time well before it had been
acknowledged to exist.

Two pieces of artwork, both of great significance, came to light
in 1968 and 1969 and revealed a new approach to art to a surprised
general public.

Ion Nita Nicodin – a rural painter from Brusturi (in the
Arad area of western Romania) – with the assistance of the art critics
Petru Comarnescu and George Macovescu, became the first of the
'*naïves*' to have his own exhibition at the Institute of Writers in Bucharest
in 1969.

Almost simultaneously, the Regional Museum at Pitesti (in
Walachia) – again with the help of specialists, on this occasion Vasile

149  **Ion Maric**
(Bacau, Moldavia)
*The Last Path*
Oil on canvas, 80 x 130 cm

Savonea, Mihail Diaconescu and Roland Anceanu – established the first permanent Gallery of *Naïve* Art in the country.

Given a new authority in this way, Romanian *naïve* art consolidated its position at an international level by being the focus of a good many more exhibitions. And the names of such artists as Ion Nita Nicodin, Ion Stan Patras of Sapanta (Maramures), Gheorghe Mitrachita of Bârca (in the Dolj area), Vasile Filip of Baie Mare (in Maramures), Alexandru Savu of Poenari (in the Dambrovitza area), Ion Gheorghe Grigorescu of Campulung Muscel (Arges), and Neculai Popa of Târpesti (Neamt) became known to a much wider audience as they were awarded various prestigious prizes and medallions. The triennial *Naïve* Art Exhibitions at Bratislava and Zagreb, and other exhibitions in Switzerland, Italy, Japan, Germany, Denmark, Norway, the Indian subcontinent, Egypt, Morocco, the United States, Canada and elsewhere were all locations at which the sensitivity, the naturalness and the purity of expression

150 **Gheorghe Mitrachita**
**(Bârca, Dolj area)**
*Country Folk at Table*
*Yesterday and Today*
Oil on canvas, 50 x 60 cm

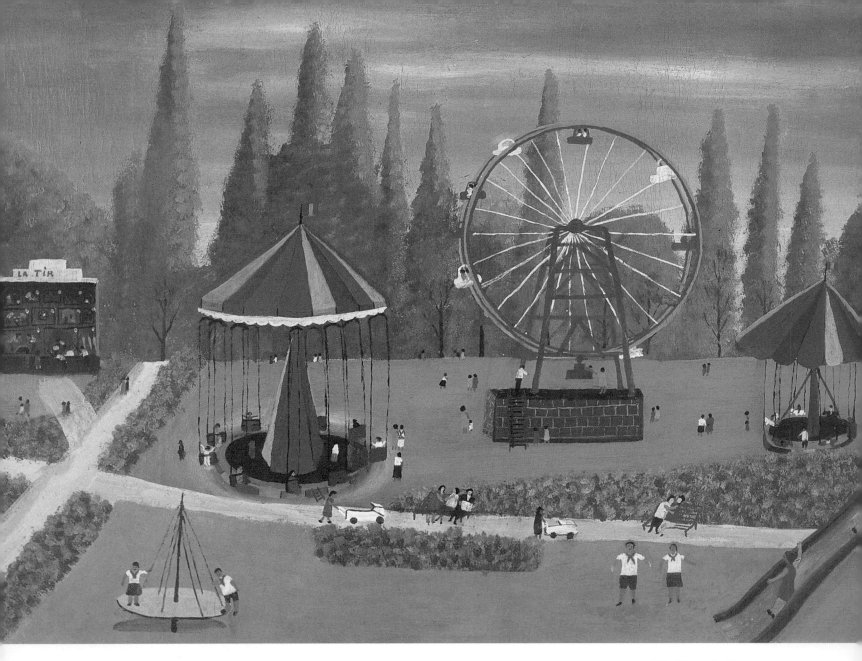

displayed by the Romanian *naïve* artists came close to overwhelming the appreciative faculties of art lovers. Best known through these international events were the artists Gheorghe Sturza, Viorel Cristea, Gheorghe Babet, and Constantin Stanica.

Among publications devoted to the subject, mention should be made of *Naïve Art in Romania*, produced in 1981 by the painter Vasile Savonea who devoted no less than 30 years to the subject, and who – despite the obfuscation of the contemporary cultural authorities – managed to impress the term '*naïve* art' on the general consciousness, and to give it a comprehensible definition as a *genre*. Another important work to place the *genre* in the international context was *Naïve Art*, edited by the critic Victor Ernest Masek and published in 1989.

The enormous changes in Romania following the historic events of 1989 opened people's eyes to new perspectives. Even though the old art *salons* continued as they always had, from 1991 onwards the biennial Exhibition of *Naïve* Art took place in Bucharest and likewise became the

151  **Gheorghe Sturza**
(Botosani)
*The Park of Distraction*
Oil on card, 38 x 47 cm

152  **Anuta Tite**
(Sapanta, Maramures)
*Preparation for a Married Future*
Oil on card, 50 x 60 cm

153  **Anuta Tite**
(Sapanta, Maramures)
*The Wedding*
Oil on card, 38 x 45 cm

**154 Toader Turda**
(Sapanta, Maramures)
*The Dance of the Young Married Woman*
Oil on wood, 60 x 40 cm

**155 Policarp Vacarciuc**
(Iasi, Moldavia)
*Nightfall*
Oil on canvas, 38 x 47 cm

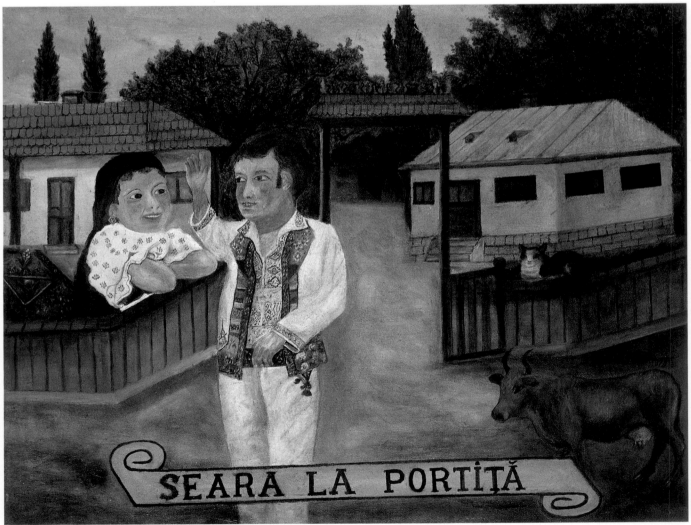

SEARA LA PORTIȚĂ

**156  Gheorghe Coltet**
(Arbore, Suceava area)
*Ox-Drawn Vehicle*
Oil on card, 42 x 56 cm

focus of interest for both artists and critics. Thanks to a new approach on the part of the civic authorities and to special efforts on the part of cultural organizations to promote this form of art, many previously closed avenues of progress were opened to Romanian *naïve* artists (by way both of national and international exhibitions and of individual and group display).

The resulting vivacity of art and artistic expression was soon apparent to all, as evidenced by the prizes awarded it. The works of Romanian *naïve* painters were to be found hanging at exhibitions, featured in specialist catalogues, and on view at the most prestigious of art salerooms. Famous – not to say celebrated – artists included Paula Iacob (of Vaslui, Moldavia), Camelia Ciobanu, Mihai Vintila, Mihai Dascalu

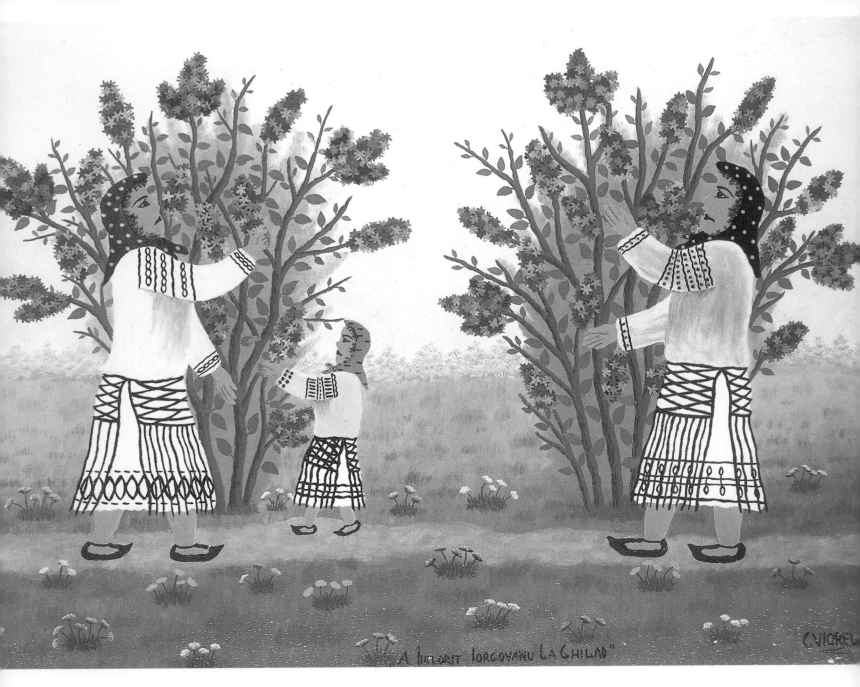

(of Resita, western Romania), Ion Maric (of Bacau, Moldavia), Gheorghe Ciobanu, Calistrat Robu (of Iasi, Moldavia), and Emil Pavelescu (of Bucharest).

The first published catalogue of the Bucharest International Salon for *Naïve* Art (1997) clearly demonstrated the creative vigour of Romanian artists – and showed too that they were more than happy for their work to be compared with the work of artists from any other country. The travelling exhibitions of Romanian *naïve* art on view in Madrid (1993), New York (1994), Venice (1995), Vienna (1996), Bangkok (1997), Thessaloniki (1997) and Paris (1998) all contributed to affirming the existence of an artistic mode that was individually Romanian. Meanwhile, the annual art courses organized for the national and international 'summer universities' attended by a country-wide student population have done much to promote the exchange of ideas and of working techniques.

157 **Viorel Cristea**
(Ghilad, Timis area)
*Harvest Time*
Oil on card, 30 x 40 cm

158 **Mihai Dascalu**
(Resita, Caras Severin area)
*Around the Mill*
Oil on canvas, 80 x 100 cm

159 **Paula Iacob**
(Vaslui, Moldavia)
*The Fishermen*
Oil on canvas, 40 x 50 cm

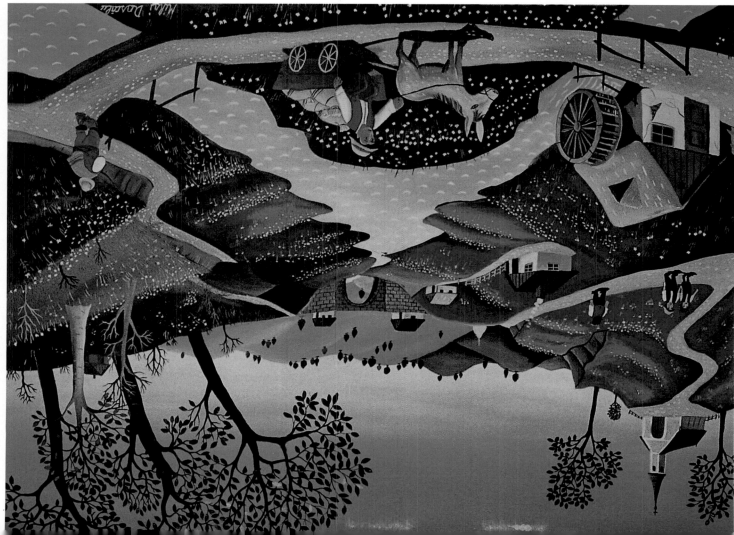

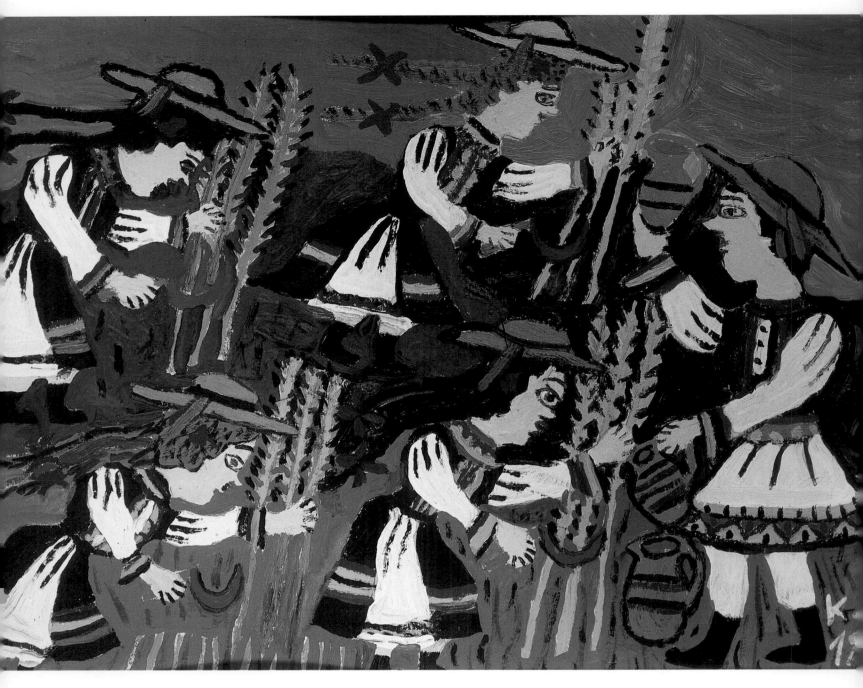

160 **Ana Kiss**
(Târgu Mures, Mures area)
*The Harvest*
Oil on canvas, 42 x 48 cm

All these new opportunities are bound also to have repercussions on the overall quality of *naïve* paintings produced. The subject matter, until current times virtually uncensured in any way, has recently been exposed to a critical disposition hardly known before 1990. New techniques have gradually infiltrated until they parallel traditional methods – so that, for example, the more vivid acrylic colours permit an artist to treat (more and) different subjects in a different manner. The lifting of cultural barriers has also granted artists direct access to displays, exhibitions and international galleries where their merit has afforded them commensurate financial reward.

Over almost 40 years of being recognized, Romanian *naïve* art – through its individuality, its originality and its sensitivity – has attained an important place in the hearts of art lovers.

161 **Alexandrina Lupascu**
(Pitesti, Arges area)
*Fishing*
Oil on card, 32 x 45 cm

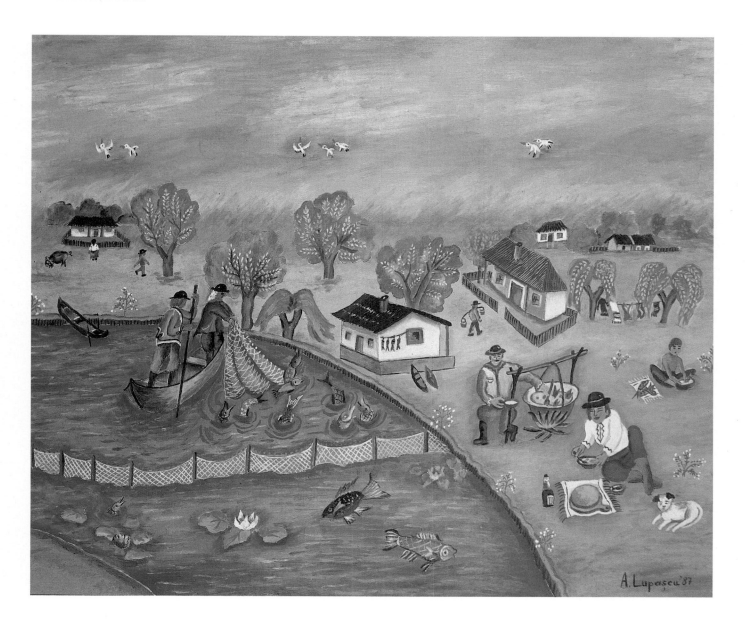

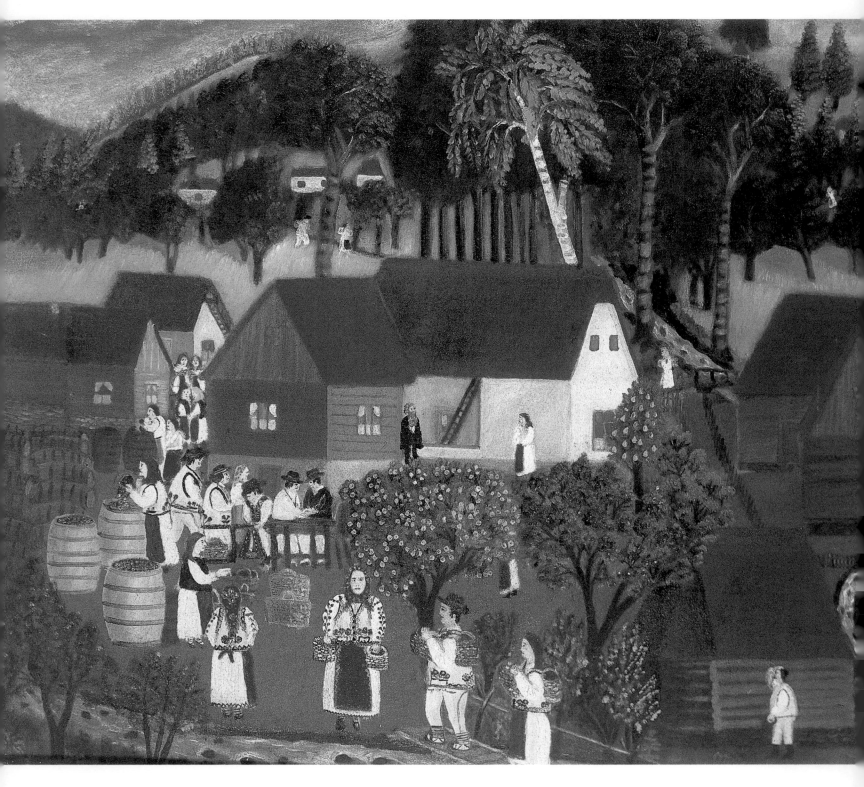

162 **Ion Nita Nicodin**
(Brusturi, Arad area)
*Harvesting the Apples*
Oil on canvas, 50 x 60 cm

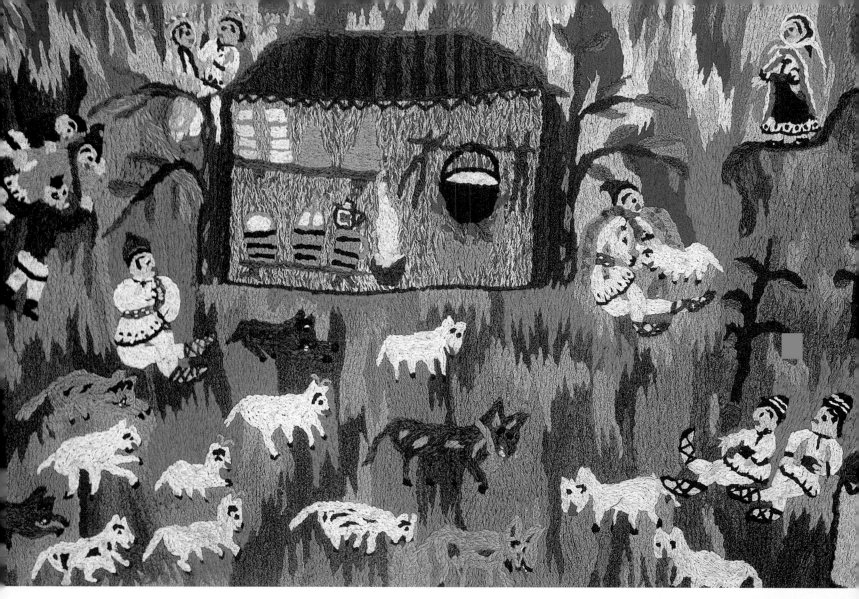

**163 Elisabeta Stefanita**
(Campulung Muscel, Arges area)
*The Sheepfold*
Tapestry, 100 x 200 cm

**164 Camelia Ciobanu**
(Resita, Caras Severin area)
*Country Landscape with Cows and Sunflowers*
Oil on canvas, 80 x 80 cm

165 **Gheorghe Ciobanu**
(Baltati, Iasi area)
*Harvesting the Fruits*
Oil on canvas, 35 x 45 cm

166 **Mihai Dascalu**
(Resita, Caras Severin
area)
*The Broken Bridge*
Oil on canvas, 50 x 70 cm

**167 Emil Pavelescu**
(Bucharest)

*Across Town By Cab*

Oil on canvas, 80 × 100 cm

**168  Emil Pavelescu**
(Bucharest)

*A View of Estoril*

Oil on canvas, 80 x 100 cm

**169  Catinca Popescu**
(Bacau, Moldavia)

*Winter in the Countryside*

Oil on canvas, 30 x 40 cm

170  **Valeria Zahiu** (Ploiesti)
*Spring*
Oil on canvas, 40 x 50 cm

**171 Camelia Ciobanu**
(Reşita, Caraş Severin area)
*The Spellbound Tree*
Oil on canvas, 100 x 80 cm

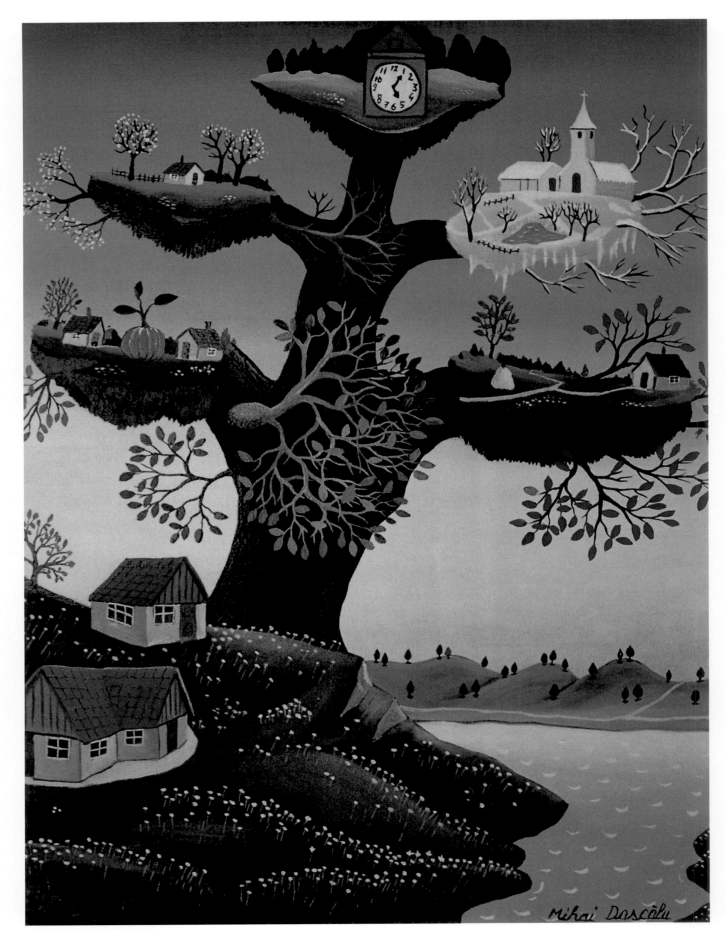

172 **Mihai Dascalu**
(Resita, Caras Severin area)
*The Spellbound Tree*
Oil on canvas, 120 x 80 cm

173 **Ion Gheorghe Grigorescu**
(Campulung Muscel, Arges area)
*The Donkey Who Made Money*
Oil on canvas, 40 x 60 cm

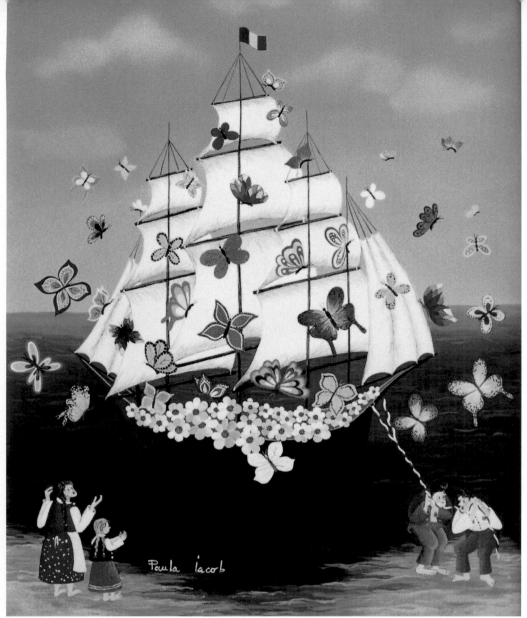

**174 Paula Iacob**
(Vaslui)
*Ship With Butterflies
and Flowers*
Oil on canvas, 70 x 55 cm

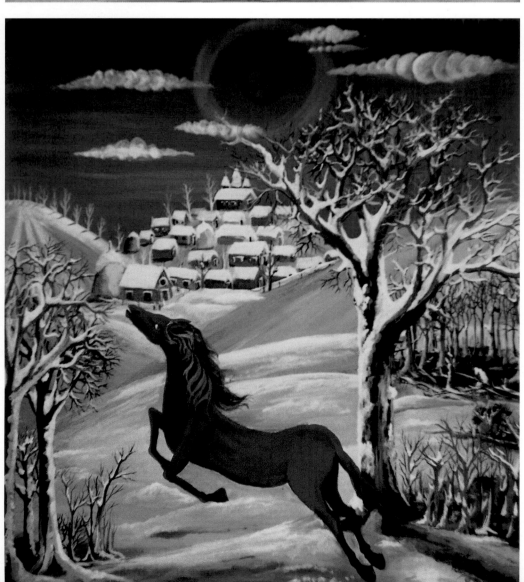

**175 Calistrat Robu**
(Iasi)
*Red Horse*
Oil on card, 60 x 45 cm

176 **Calistrat Roby**
(Iasi, Moldavia)
*The Giant Fish*
Oil on canvas, 70 x 50 cm

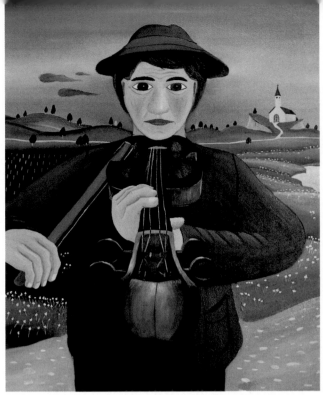

177 **Mihai Dascalu**
(Resita, Caras Severin area)
*The Violin-Player*
Oil on canvas, 120 x 80 cm

178 **Vasile Filip**
(Baie Mare, Maramures)
*Portrait*
Oil on canvas, 50 x 42 cm

179 **Ion Gheorghe Grigorescu**
(Campulung Muscel, Arges)
*The Organ-Player of Barbary*
Oil on canvas, 60 x 45 cm

...ŞI CU SERGENTUL, ZECE.

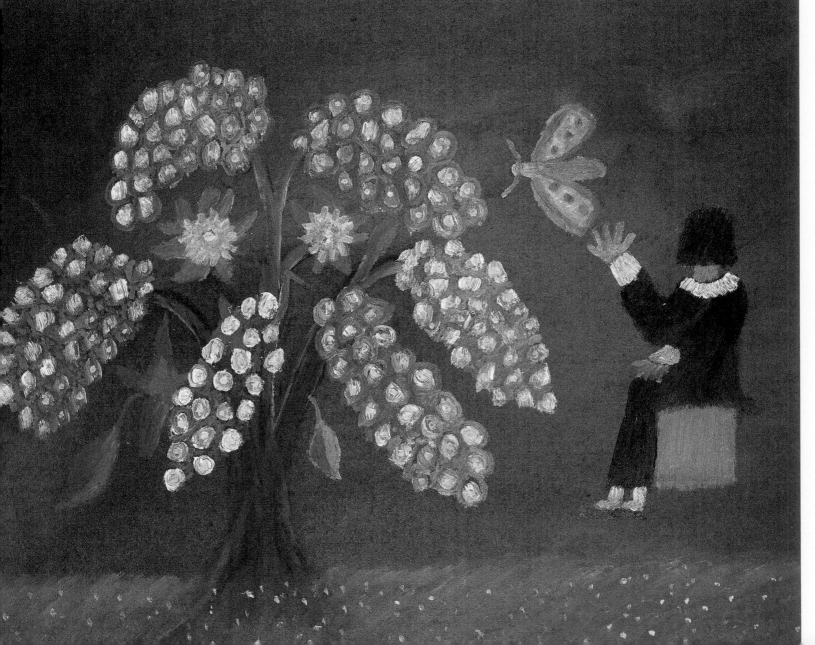

180 **Ion Pencea** (Iasi)
*. . . And With the Sergeant*
*That Makes Ten*
Oil on canvas, 50 x 55 cm

181 **Onisim Babici**
(Chiuzbaia, Maramures)
*Flowers*
Oil on canvas, 40 x 45 cm

182 **Constantin Stanica**
(Bucharest)
*The Lilies*
Oil on canvas, 45 x 40 cm

**184 Traian Ciucurescu**
(Brasov)

*The War of Independence, 1877*

Oil on glass, 30 x 25 cm

**185 Mircea Corpodean**
(Cluj)

*Prince Michael Viteazul and the Turks*

Oil on glass, 40 x 30 cm

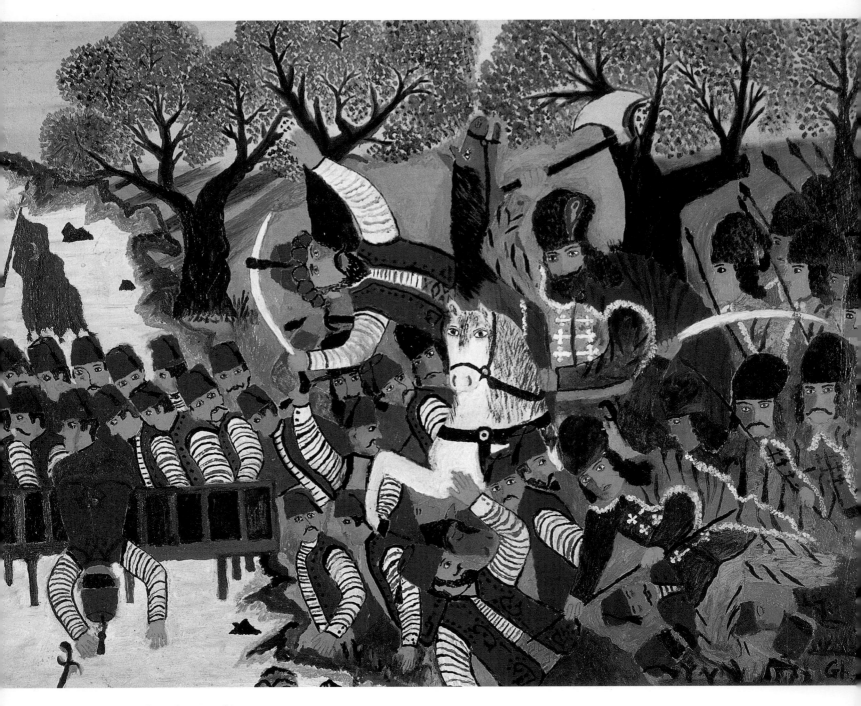

186 **Gheorghe Mitrachita**
(Bârca, Dolj area)

*Prince Michael Vitreazul
and the Turks*

Oil on canvas, 60 x 80 cm

187 **Emil Pavelescu**
(Bucharest)
*The War of Independence,
1877*
Oil on canvas, 55 x 80 cm

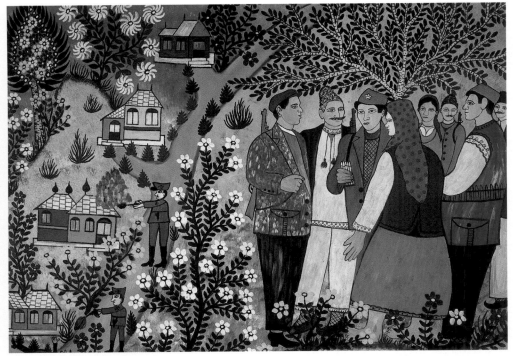

**188 Alexandru Savu**
(Poenari, Dambovitza area)
*The Years of the Revolution*
Oil on card, 30 x 40 cm

**189 Constantin Stanica**
(Bucharest)
*The Attack on Plevna*
Oil on card, 40 x 53 cm

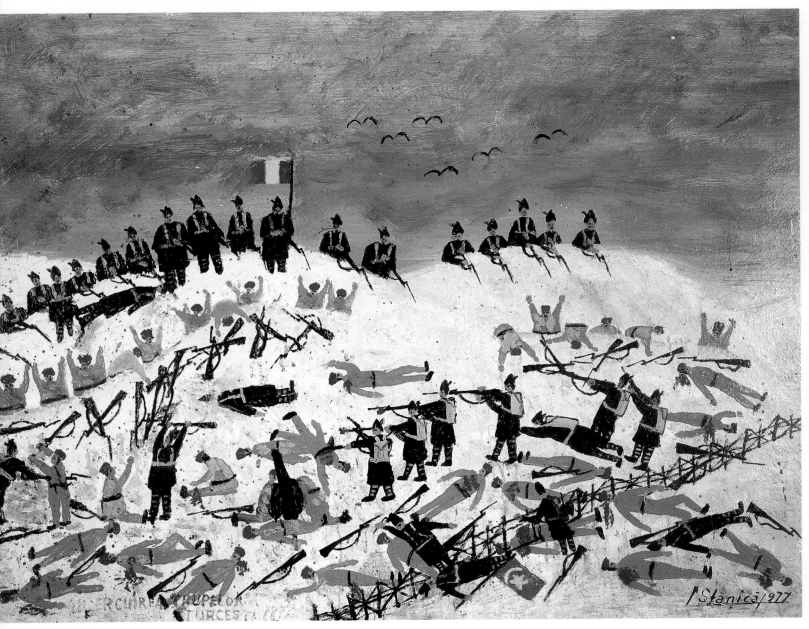

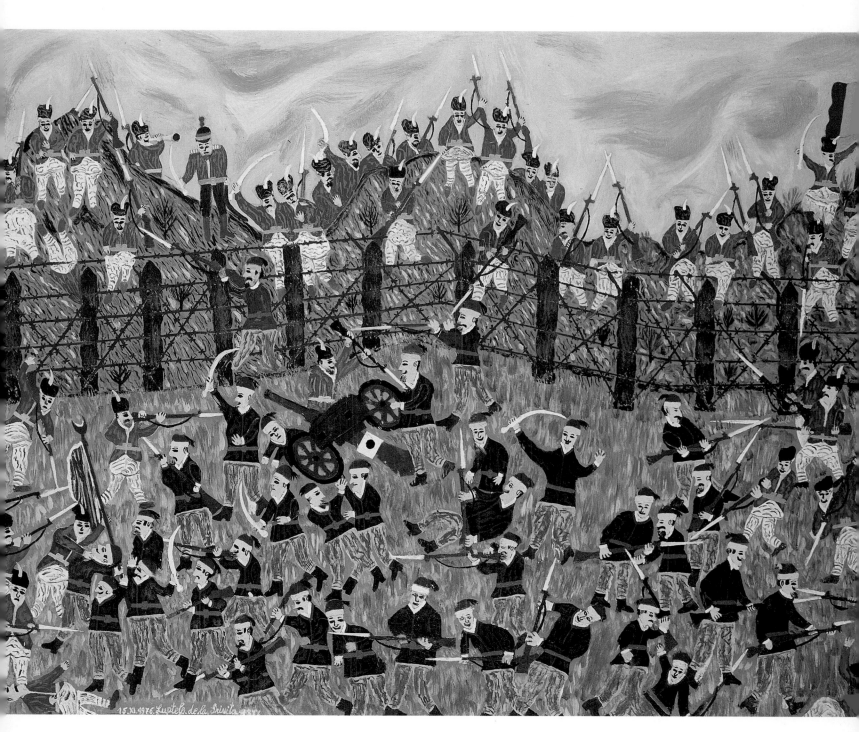

190 **Gheorghe Sturza**
(Botosani)
*The Attack*
Oil on canvas, 43 x 58 cm

# Is Naïve Art Really Naïve?

## *Naïve* Artists and Professional Artists

Once when I was in a small town in Estonia during the mid-1960s, I was lucky enough to meet an elderly landscape painter. With a small brush he was making neat strokes with oil-paint on specially prepared cardboard. In the foreground he was establishing a pattern of lacy foliage, while clusters of trees in the background created large circles. He was building up spatial perspective according to the classic method - with a transition from warm to cold colours - although the contrasts between yellow, green and blue tonal values in the foliage were transforming what was an overgrown park into a magical forest.

The artist told me that he had created his first works way back during his childhood. There then followed a gap of many decades during which he was employed at the local match factory. He returned to painting only upon his retirement. He insisted that he had never been outside Estonia, had never seen works of art at the Hermitage - the nearest large art museum (in St Petersburg, Russia) - had no knowledge about other European art or artists, had never himself attended any kind of formal art training, and was not acquainted even with any other 'Sunday artists'. It was difficult to believe him, for his work was distinctly reminiscent of the landscapes of Jacob van Ruisdael, Meindert Hobbema and Paul Cézanne. If he was telling the truth, how can such a likeness be explained? If he was not telling the truth - why not?

Not only did *Naïve* Artist Number One, Henri Rousseau, make no attempt to conceal his admiration for professional art - on the contrary - he made it evident on every possible occasion. He idolized those professional artists who received awards at the *salons* and whose works were despised as academic banalities by the avant-garde artists. In his autobiographical jottings he loved to name-drop, mentioning particularly advice given to him by Clément and Gérôme. When he received permission from the authorities in 1884 to make copies of paintings in the

national galleries such as the Louvre, the Musée du Luxembourg and Versailles, Rousseau told others (including Henri Salmon, who repeated it later) that he was going to the Louvre 'in order to seek the Masters' advice'. His pictures thereafter testify that he knew how to put this advice into practice. The most diligent of Academy graduates might have been envious of his working method. He made many drawing and sketches *in situ*, paid close attention his painting technique, and thoroughly worked the canvas surface. The condition of Rousseau's paintings today is much

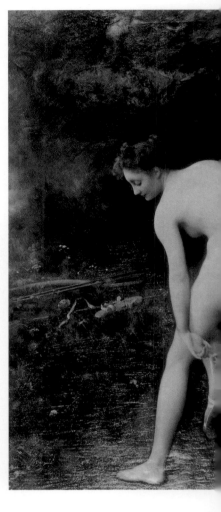

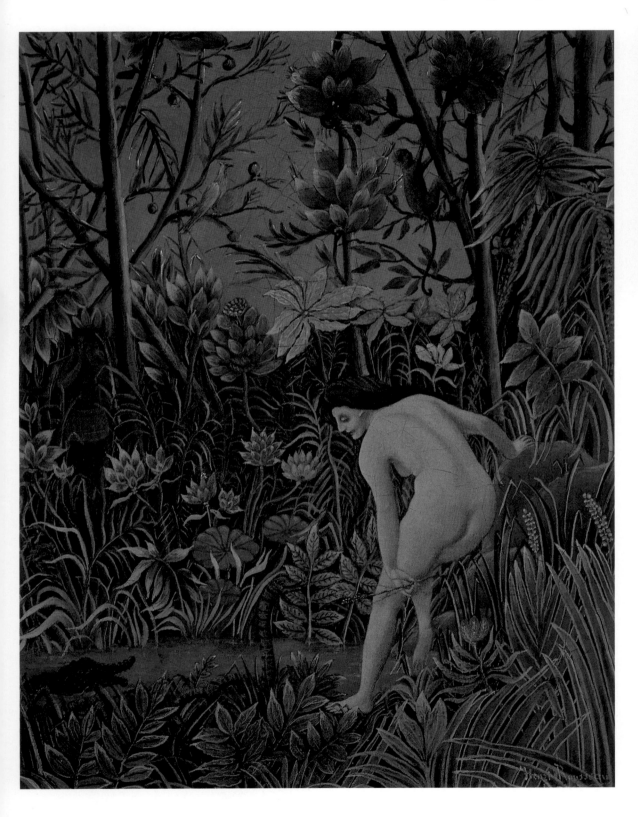

**191 Henri Rousseau**
*The Spell*, 1909
Oil on canvas, 45.5 x 37.5 cm
Museum Charlotte Zander,
Bönnigheim Castle

better than that of many of the professional artists of the time. His work
was never spontaneous, details were never an end in themselves, and
each picture has an overall integrity of composition. His virtuoso
brushwork inspired admiration, and the refinement evident in his
technique is reminiscent of the paintings of Jean-Baptiste-Camille Corot.

It is in Rousseau's attempts to render perspective that his
limitations become obvious. The lines often do not converge at the correct
angle, and instead of receding into the distance his paths tended to climb
up the canvas. Perhaps we ought to remember, however, that Rousseau
himself said in one of his letters that 'If I have preserved my naïveté, it is
because M. Gérôme... and M. Clement... always insisted that I should
hang on to it.'[34] But in view of the imperfections of his painting it is
difficult to believe that they all stem from the deliberate rejection of the
scientific principles of perspective laid down by Leonardo da Vinci and
Leon Battista Alberti.

The history of art affords us a number of excellent examples of
artists who became professional only at a mature age and managed
nonetheless to master that science of painting that comes much easier to
those who are younger. The number is, however, not large. Only a few
outstanding individuals - like Paul Gauguin and Vincent van Gogh - are
capable of such achievement. For all that, striving for the 'correct' way to
paint and endeavouring to follow methods taught in art schools and
practised by the great masters is a trait present in almost every *naïve*
artist.

**193 Leonardo Da Vinci**

*The Annunciation*,
ca 1473-75
Oil on wood, 98 x 217.2 cm
Galeria degli Uffizi, Florence

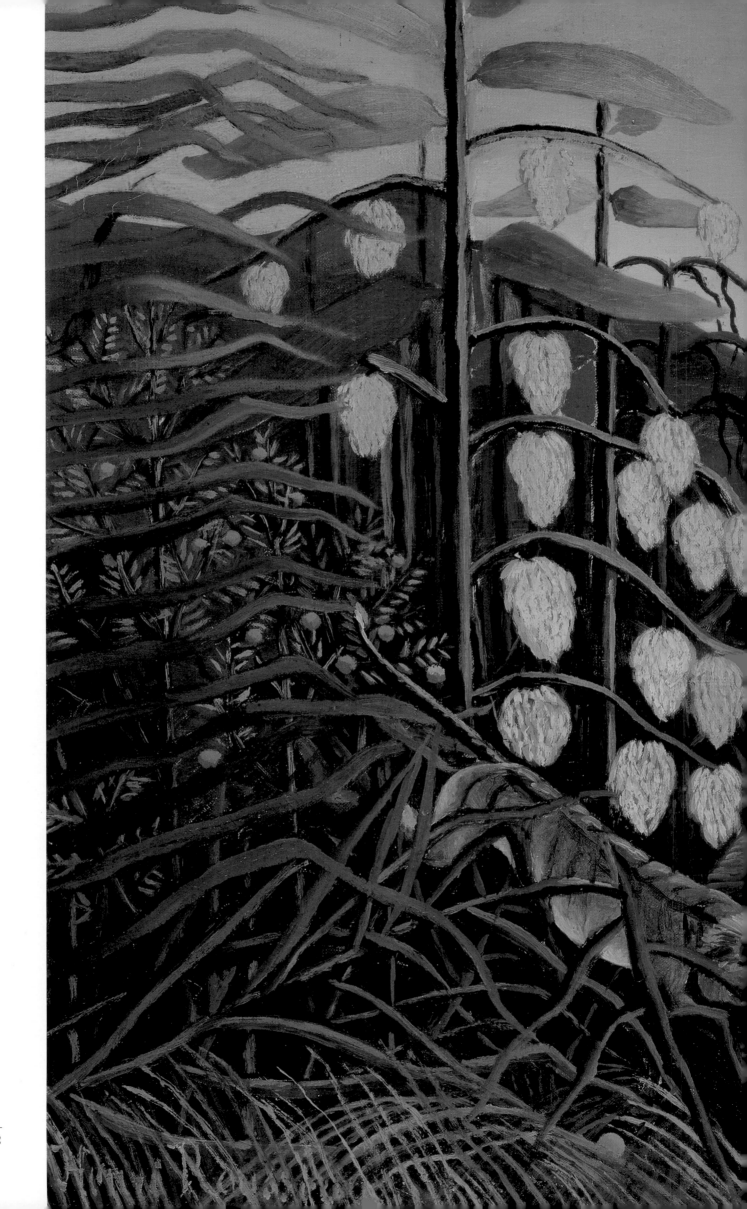

Although Niko Pirosmani had no Hermitage or Louvre to visit, he was familiar with the works of other artists in contemporary Tbilisi, and tried to follow the professional 'rules' as far as he could. Perspectives in his landscapes, however, the anatomical proportions of his models and the positioning of human figures within his pictures were all prone to the errors also to be seen in the works of Le Douanier Rousseau. They reveal that characteristic awkwardness common to artists who start painting as adults. But like Rousseau, Pirosmani took great pride in his own individuality.

Despite the amazing diversity of *naïve* artists, then, their relationship with professional art is basically the same. It would, after all, be extremely difficult to find a person who took up a brush and just

195 **Henri Rousseau**
*A Tribute to the Republic*
Oil on canvas

194 (see pages 182–3)
**Henri Rousseau**
*In the Rain Forest*, 1908
Oil on canvas, 46 x 55 cm
Hermitage, St Petersburg

started creating oil paintings without any previous knowledge of painting and without ever having seen the pictures of the great masters even by way of reproductions on postcards.

Moreover, the seeds of this knowledge has fallen on to many different sorts of ground. The landscapes of Ivan Generalic, for example, are remarkable for their classical construction and spatial perspective. His figures move with such expression that those of Claude Lorrain and Pieter Bruegel spring to mind. He most probably owed these qualities to his mentor, Hegedusic. The other Croatian rural artists of Hlebin quite often established perspective in stages up the canvas, and their portrayals of the human figure were little or no more than childish.

Analysis of *naïve* art against professional criteria points to the conclusion that French and German, Polish and Russian, Latin American

**196 Niko Pirosmani**
*Yellow Lion Sitting*
Oil on cardboard, 100 x 80 cm
Georgian Museum of Fine Arts, Tbilisi

and Haitian artists all have some qualities in common. On the one hand all of them have a fairly clear idea of art as taught in art schools, and strive towards it. On the other hand they all possess that clumsiness which results in a characteristic manner of expression and which is itself responsible for the lack of balance in their works, resulting in outlandishly bold exaggeration or, conversely, in painstaking attention to detail. These, though, are the very qualities for which *naïve* artists have become best known.

At the same time, if an adult person finds himself or herself striving earnestly towards an artistic goal and yet comes to the realization that his or her limitations make the goal unattainable, he or she might well be tempted to conceal any familiarity with the basics of art. Indeed, André Malraux once described Rousseau as being 'able to get what he wants like a child, and slightly devious with it'.

**197 Claude le Lorrain**
*Italian Landscape*, 1648
Oil on canvas, 75 x 100 cm
Hermitage, St Petersburg

**198 Milan Rasic**
*My Village in the Spring*

# Notes and Bibliography

1  Charles Schaettel, *L'art naïf*, PUF, Paris, 1994, p.58
2  Gerd Claussnitzer, *Malerei der Naiven*, Seemann Verlag, Leipzig, 1977
3  M. Genevoix, *Vlaminck*, Paris, 1983, p.31
4  Quoted by Agnès Humbert, *Les Nabis et leur époque*, Pierre Cailler, Genève, 1954, p.137
5  Quoted by Jean Laude, *La peinture française et l'Art nègre*, Klincksieck, Paris, 1968, p.105
6  *Ibid.*, p.10
7  *Le Douanier Rousseau*, Galeries nationales du Grand Palais, Paris, 1985, p.262
8  *Le Banquet du Douanier Rousseau*, Tokyo, 1985, p.10
9  A. Salmon, *Souvenirs sans fin, deuxième époque 1908-1920*, Gallimard, Paris, 1956, p.49
10  G. Coquiot, *Les Indépendants 1884-1920*, Librairie, p.130
11  *Ibid.*, p.132
12  M. Chile, *Miró, L'artiste et l'œuvre*, Ed. Maeght, Paris, 1971, p.10
13  Léonard de Vinci, *Œuvres choisies*, tome 2, Moskva, Leningrad, 1935, p.112
14  Quoted by E. Kojina, *Romantitcheskaïa bitva*, Iskoustvo, St Petersburg, 1969, p.250
15  Victor Hugo, *Notre-Dame de Paris*, Gallimard, Paris, 1966, p.190
16  *Ibid.*, p.186
17  *Ibid.*, p.187
18  *Ibid.*, p.159
19  *Ibid.*
20  *Ibid.*, p.156
21  A Povelikhina, E. Kovtoun, *Russian Painted Signs and the Avant-Garde Artists*, Aurora, St Petersburg, 1991, p.186
22  *Ibid.*, p.157
23  *Ibid.*
24  Walter Benjamin, *Journal de Moscou*, Ed. l'Arche, Paris, 1983, p.28, traduction de Jean-François Poirier
25  Ibid., p.29
26  *Das Naive Bild der Welt*, Baden-Baden, Main, Hannover, 1961, p.87
27  A Povelikhina, E. Kovtoun, *Op. cit.*, p.72
28  K. M. Zdanevitch, "Niko Pirosmanashvili", *Iskutsvo*, Moscow, 1964, p.80
29  *Ibid.*
30  *Ibid.*, p.10
31  *Ibid.*, p.25
32  K. M. Zdanevitch, *Op. cit.*, pp.10–11
33  *Ibid.*, p.13
34  *Le Douanier Rousseau*, Galeries Nationales du Grand Palais, Paris, 1985, p.37

# Picture List

# A list of paintings alphabetically by painters